DESIGNING WITH
TWO COLORS

TWO COLORS
TWO COLORS
TWO COLORS
TWO COLORS
TWO COLORS
TWO COLORS
TWO COLORS
TWO COLORS
TWO COLORS

TWO COLORS
TWO COLORS

DESIGNING WITH TWO COLORS

BETTY BINNS

WITH SUE HEINEMANN

A ROUNDTABLE PRESS BOOK

WATSON-GUPTILL PUBLICATIONS / NEW YORK

017361

ACKNOWLEDGMENTS

Many people helped in the preparation of this book. We particularly wish to thank John Schaedler and his staff at Schaedler-Pinwheel in New York City for preparing the film for the various halftones, duotones, and special effects shown in Chapters 4 to 7. Schaedler-Pinwheel's names for the particular special-effect screens are: Conventional Needlepoint with Galaxy (page 52 middle), Line Rendering with solarization (page 52 bottom, page 59 right), Line Rendering with halftone (page 57), Laser Grain (page 58), Conventional Needlepoint with Posterized Needlepoint (page 59 left), and Line Rendering (page 61). We also thank Letraset for allowing us to reuse Betty Binns's designs on pages 62–64, 94–96, and 111–112; Norman Nuding, for the art on page 46; Ray Skibinski, for the art on page 48; and Judith Cummings and Stefan Rudnicki, for the repeated use of their photographs of each other. Bill Broecker kindly converted our disks when we moved from one computer to another. Martin Lubin, David Skolkin, and Mariana Francis at Binns & Lubin all helped in various ways. Most of all, we wish to thank Susan E. Meyer and Marsha Melnick of Roundtable Press, who came up with the initial idea for this book and provided advice and encouragement at every step along the way.

A ROUNDTABLE PRESS BOOK

Directors: Marsha Melnick and Susan E. Meyer

Copyright © 1991 by Roundtable Press, Inc.

Published by Watson-Guptill Publications,
a division of BPI Communications, Inc.,
1515 Broadway, New York, NY 10036

Library of Congress Cataloguing-in-Publication Data

Binns, Betty, 1929–
 Designing with two colors / Betty Binns with Sue Heinemann.
 p. cm.
 "A Roundtable Press book."
 Includes bibliographical references and index.
 ISBN 0-8230-1334-0
 1. Color in design. I. Heinemann, Sue, 1948– . II. Title.
Nk1548.B56 1991
741.6–dc20 90-13113
 CIP

PRINTED IN THE UNITED STATES OF AMERICA

First printing, 1991

1 2 3 4 5 6 7 8 9 10 / 96 95 94 93 92 91

CONTENTS

PREFACE

This book is both a sourcebook of ideas for designing with
two colors (specifically, one color plus black) and a guide
to which kinds of color work best in particular situations. In
general, how you intend to use a second color determines
which color you choose. To help you with that choice, this
book focuses on four color categories: warm (reddish) or
cool (bluish), clean (pure) or dirty (mixed with black). The
same images are reproduced in a dirty warm, a dirty cool, a
clean cool, and a clean warm color. The image's impact
varies depending on the color; if you flip from one color
version to another, you can clearly see the differences.

For the most part, dirty colors offer the most flexibility.
Although clean colors can be alluring, they can be difficult
to use, as demonstrated in some examples here. A caution
is also needed. Several examples that work well require
multiple screens, making the job more costly.

The varied examples should help you determine the
appropriate category for the effect you want. Altogether the
examples are designed to spark your imagination and
encourage you to take full advantage of two-color printing.

TECHNIQUES FOR
TWO-COLOR PRINTING

Many designers view using only two colors as a major limitation, especially if one of the two colors is black. What they fail to realize is just how many variations are possible with this restricted color scheme. To begin, two-color printing in fact involves three colors—not only black and the second color, but also the white of the paper. Just "mixing" these colors in different ways gives you about 100 tones to choose from (although some may not be distinct enough to use). Now think of all the different elements in a design—each of which must be considered in terms of color. Even a simple bar graph like the one on page 38 can be treated in many ways. In fact, the 24 variations shown here are only a sampling of the possibilities.

The beauty of two-color printing is that you can arrive at all these variations with just a few basic techniques: printing solid colors, screening colors, surprinting, knocking (or dropping) out, and trapping. Whether you use traditional mechanicals or create film from a computer disk, preparing for printing is relatively simple and easy to learn.

PRINTING SOLIDS

The simplest choice is to print a color at full strength, as a solid—a choice also referred to as 100% color (or 100% black, if that is the color). Essentially there are two ways of using solids: either as line or to cover an area that can range from a small dot to the entire sheet. Effective two-color pieces can be created using solid colors alone—without any other techniques. The key lies in the design, not the complexity of the technique (Figs. 1–2).

If you decide to use solids in large areas, however, there are some printing problems you should be aware of from the start. Large areas can be difficult to cover on press—sometimes requiring two or more passes (which makes it more than a two-color job). Large, dark solid areas may show fingerprints, and a full-page solid on uncoated paper may scuff easily. To avoid these problems, you might ask your printer about adding a varnish, either over the whole sheet or in spots. Keep in mind, though, that a varnish tends to deepen the ink color and change the color of the white paper. It also adds to the cost of the job (in essence, it is an extra color).

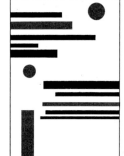

1 Design with solids

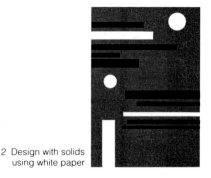

2 Design with solids using white paper

SCREENING COLOR

Another basic choice is to use a tint, or flat tone, of a color (Figs. 3–4). Tints are created by screening the color at a specified percentage so that it reproduces as a regular pattern of equal-size dots. The larger the dot, the darker and purer the color; with smaller dots, more of the white paper shows through so the color appears lighter.

Figure 5 shows various tints of black and red from 10% to 100%, as well as combinations of these tints. Keep in mind that very dark or very light tints may not be distinguishable on press. Below 7% may be too light to read or may seem indecisive; above 80% may not differ sufficiently from full strength.

Even if you chose only a dark, a middle, and a light tone of each hue, you would have 10 colors to work with: pure red, medium red, light red, pure black, middle gray, light gray, dark red-black, medium red-black, light red-black,

3 Design with tints

4 Design with tints and solids

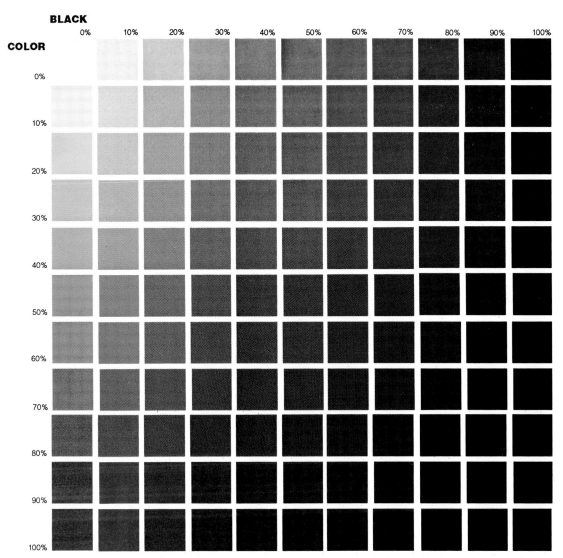

BLACK

COLOR

5 Range of tints with two colors

and—easily forgotten—white. Again, what counts is not the number of colors you use, but how you use them.

In creating a tint, you need to consider not only the percentage of color but also the number of lines of dots per inch in the screen. A very coarse screen might have only 85 lines per inch; a fine one would have 150. With a coarse screen you can usually see the dots with the naked eye; a fine screen gives you a more even, "flatter" tone (Fig. 6). In addition to these considerations, the choice of screen depends on the paper you intend to use (see page 28).

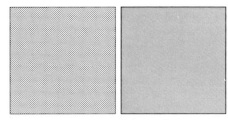

6 Same tint with 65-line (left) and 150-line screen

SURPRINTING

To extend the color possibilities, you can surprint, or overprint—printing one color or tint on top of another. Take a look at Figure 7. Here the same shade of red was surprinted over different screens of black (different grays). Compare this result with Figure 8, where black is surprinted on different screens of red. As you can see, when the red is printed on gray, it picks up some of the color below. In contrast, when black (or any other very dark color) is surprinted, it masks out the color below. If you are printing type on a color background, you may prefer to obscure the bottom color. But take care not to print a lighter color on a solid dark—such as a red on a solid black. The lighter color will not be visible; the area will remain solid black.

When you decide to surprint, it's important to keep in mind that the same color printed on white and on a gray tint will not look the same, unless you are using a very dark color. Don't plan to have a bar of color surprinted on a gray page match a bar of the same color surprinted on a white page, as in Figure 9. To make the two bars match optically, on the white page you must surprint the red bar on a gray bar (the same shade as the gray page), as shown in Figure 10. In each case, then, the red surprints on the same screen of black.

The way a color surprints on gray can even play an important part in your choice of a second color. There are times when you may select a second color specifically because of the way it combines with a percentage of black. If, for example, your design features a gray background,

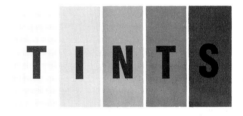

7 Red surprinted on different percentages (10, 20, 40, 60, 80) of black

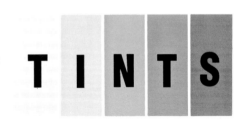

8 Black surprinted on different percentages (10, 20, 40, 60, 80) of red

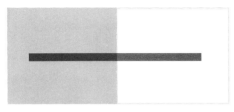

9 Solid red surprinted on 30% black and white

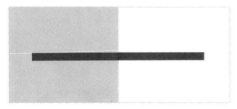

10 Solid red on 30% black; red plus 30% black on white

11 Type knocked out to white

12 Type printed in 100% red

13 Type knocked out and then printed in 100% red

with type or an image surprinting on this background, your second color should be chosen for the way it combines with the background. Visualizing how a second color will print on gray is largely a matter of experience, although a few printers have charts similar to Figure 5. (You can also have one specially prepared, but this may be expensive.) One reason for planning the printed result in this way is that by surprinting you can avoid some of the problems that are described below.

KNOCKING OUT AND TRAPPING

The terms "knock out," "drop out," and "reverse" all refer to the same process. They instruct the person shooting the mechanical or art to mask a designated area—usually an image or type—so that only the white paper will appear in this area. This may be all that you want. For example, if you want white type on a black background, you would ask for the type to be knocked out to white.

But it is also possible to print a second color in this knocked-out area. Now another mask is needed, with the background masked out, so that the second color will print only within the contours of the area that has been knocked out. Figures 11–13 show how the word "color" can be knocked out to white from the black background and then printed in 100% red. The advantages of this technique should be obvious. As we already noted, red will not be visible on black if you simply surprint it. By knocking out first, the color essentially prints on white and thus retains its full strength.

The problem with this process is that the knocked-out area and the type or image in the second color must be in perfect register—that is, they must fit exactly. To accomplish this, printers use a technique called "trapping," in which they let the two colors overlap slightly so that there is no chance of a white line showing in between them.

Even trapping, however, has its limitations. For it to work, there must be a distinct difference in value between the two colors that will overlap. Moreover, if you want two tints to meet, it is almost impossible to get a clean line between them. Most printers will advise you to include, as

part of your design, a solid black line—or at least some white space—between the two tints (Figs. 14–16).

Traditionally designers have been advised not to use fine serifs, small type, or very detailed images with knocking out and trapping, as a certain amount of definition may be lost. Even if you are simply knocking out a block of type on a black background, you may want to choose a boldface for legibility. Improved technology, however, is changing the traditional caveats in this area. With a good printer and the latest equipment, even fine serifs can be knocked out.

A common dilemma arises when the design calls for type over an area that has varying tones—as a photograph does. When should you knock out and when should you surprint?

Figure 17 compares the results of surprinting and knocking out on different tints and combinations of red and black. The real question here is: Which technique gives you the greatest contrast? Obviously it is best to avoid a design where the type will print on a background of the same value. When in doubt, ask your printer for advice.

14 Black line between tints

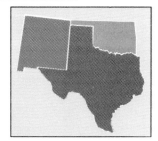

15 White space between tints

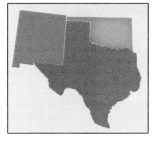

16 Tints butting

HALFTONES

Printing could be described as a binary operation: an area either receives ink or it does not. There are no inbetweens—or shades of gray. Thus continuous-tone art—such as a photograph, watercolor rendering, or tonal drawing, with its subtle gradations from white to black—has to be converted into a dot or line pattern for printing. If you take a close look—through a loupe—at all the photographs reproduced in this book, you will discover that the appearance of continuous tone is an illusion. All are made up of tiny dots of black (and/or a second color) with areas of white in between.

The process used to create the dot pattern is called the "halftone" process. The name itself suggests a limitation of the technique, for only a fraction ("half") of the tones in the original photograph remain after the image has been translated into dots—just as only a fraction of the tones we see in nature survive the translation through the camera's eye into the black-and-white photograph. Moreover, the

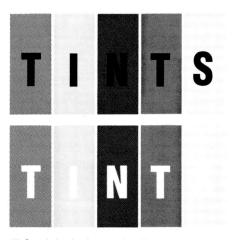

17 Surprinting (top) versus knocking out

18 Halftone shot with 65-line (left) and 150-line screen

19 Normal mid-range halftone

20 Flash (left) and bump exposures

halftone will go through several additional translation processes on press before the final result appears on paper. Although the losses here are subtle, they underline the need for a top-quality photograph with good contrast at the start.

Traditionally halftones have been created by photographing the image with a copy camera. More and more, however, electronic scanning is being used. This method has several advantages. First, it is able to recognize 10 to 20 times as many gray tones as the copy camera, so the resulting images are truer to the original, with finer detail. Even more, it allows you to improve on the original—for example, by increasing overall sharpness or changing the relative density of light and dark areas. You can even widen or elongate the image, as long as the resulting distortion is not critical.

Although a good printer (or separator) will determine the best way to reproduce a photograph or tonal drawing, it always helps to know something about the process. An important factor in halftone quality is the screen used in shooting the negative. These screens range from 55 lines per inch to 300 lines per inch and even higher. With more lines, there are more dots, and the dots themselves are smaller, allowing for a greater range of tones and finer details (Fig 18). However, more is not necessarily better; there are other factors to consider, such as the paper and press being used, as well as the care taken by the printer. On coarse paper, for example, a 65-line screen may hold more detail in the shadows than a 150-line screen (see the discussion on page 28). With a better, less absorbent grade of paper, a 133- or 150-line screen may be quite adequate; with a finer screen, you may actually lose more detail in the shadows on press.

Another aspect that affects the quality of a halftone is the camera exposure (Figs. 19–20). To get the full impact of a photograph, more than one exposure may be necessary. Sometimes, for example, although the main exposure captures the middle tones accurately, there is a lack of detail in the highlights or shadows. To get more definition in the shadows, a second, *flash* exposure could be used—essentially flashing light into the shadows. To increase detail in the highlight areas, what is called a *bump* exposure could be used. The use of two different exposures can be particu-

larly important with duotones, which are printed in two different inks (see below). While it isn't necessary for you to specify the type of exposure, you should let the person operating the camera know if you are particularly concerned about detail in the highlights or shadows.

In terms of design, there are several different ways of reproducing halftones. Most often, the image is reproduced as a *square halftone*, appearing as a square or rectangle, with right-angle corners (Fig. 22). Another possibility is to *silhouette* the image, removing the background so that the image floats on the white paper (Fig. 23). (This is also called an outline halftone.) A related choice is the *dropout halftone*, where you ask the printer to remove all dots from the highlight areas, making the highlights even more brilliant (Fig. 24). With pencil or wash drawings, a dropout halftone is often requested so that the white paper of the original drawing won't acquire a tone from the halftone dots. Here it is important for there to be a sufficient distinction between the white paper and the lightest tone in the drawing, or you may lose some detail.

A fourth possibility is to *vignette* the halftone, so that the edges fade into the background (Fig. 25). With a cast shadow, for example, the dots can be gradually erased so that the shadow disappears into the white of the paper. Yet another option is a *ghost halftone*, where a flash exposure is used to lighten the entire image, which then appears ghost-like (Fig. 26). In requesting this kind of halftone, it is best to tell the printer how dark you want the darkest tone—for example, "make darkest black 40%."

A ghost halftone is frequently surprinted with type. In this case you need a combination of line and halftone, where the type and image are photographed separately before being combined. You can also have a combination shot using a full-strength halftone, with the type either surprinting or dropping out, as discussed above.

DUOTONES

Two-color printing expands the possibilities with halftones even further, allowing you to use duotones. In a duotone the image is shot (or scanned) twice—with the angle of the

21 Square halftone

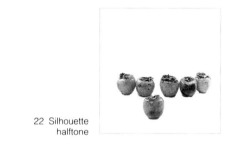

22 Silhouette
 halftone

23 Dropout halftone

24 Vignette halftone

25 Ghost halftone
 (darkest areas 40%
 black)

26 Normal mid-range halftone

27 Highlight halftone in color

28 Duotone with Figure 26 as black plate and Figure 27 as color plate

29 Same duotone as Figure 28 but with color plate screened back to 60%

30 Duotone using Figure 27 as full-value black plate and Figure 26 as color plate screened back to 60%

screen shifted slightly in the second shot—-and two different plates are made from these exposures. This process has an immediate advantage: it lets you combine two different exposures and thus increases the tonal range of the printed photograph. You might, as noted above, concentrate on the highlights and middle tones in the main exposure and use a separate flash exposure to bring out detail in the shadows. Both plates can then be printed with the same black ink —producing what is called a double-dot duotone. Even though only one ink color is used, this is two-color printing. The photograph will appear richer, with stronger darks, than a conventional halftone.

The same two plates could, of course, be printed in two different colors—either two different blacks (warm and cool) or black and another color. The second color not only increases the range of the photograph; it can also shift the mood or enliven an ordinary image.

The choices with duotones extend beyond the hue of the ink. You can also vary the amount of color used. You might, for example, request 100% black for one plate and 60% color for the other—or vice versa. As Figures 26–30 show one image can be reproduced in a multitude of ways.

Because duotones are more expensive to create than halftones, you may be tempted to fake a duotone by combining a screen of flat color with a halftone. If your aim is to achieve a greater tonal range, the result is definitely inferior, as you can see from the top example on page 50. In particular, note that the lack of any pure white highlights reduces the overall contrast. There may, however, be design situations when combining a flat tone and a halftone is just the look you want.

SPECIAL EFFECTS

Continuous-tone art can also be converted into line using a special-effect screen rather than a conventional halftone screen. You can choose a screen with straight lines (horizontal or vertical), wavy lines, or circular lines. Depending on the design effect you want, you might prefer an extra-coarse screen, in which the dots are quite visible, becoming a design element in themselves. Or you might decide on a

tone line conversion or a mezzotint screen, giving the image a soft, grainy look. For a more graphic impact, you might ask for a high-contrast line conversion, which reduces the image to areas of black and white (eliminating all the grays). A related technique here is posterization, which simplifies the tones into black and white, with a few grays in between—giving the image a flat, posterlike look.

The availability of a second color obviously expands all these possibilities. Again, you can work with percentages of color, either for the image or the background. (See pages 52, 58, 59, and 61 for examples that take advantage of special effects in two-color printing.)

PREPARING COPY AND ART FOR PRINTING

Knowing what is possible with two-color printing is not enough. To get good results, you must be able to communicate exactly what you want to the printer (or separator). The first step is to get guidance from the printer on how the material should be prepared. Printing technology is changing rapidly, and certain tedious pasteup chores can now be done more quickly and more economically—and even more accurately—by the printer. Although one printer, for example, may still prefer that you cut a mask, or Rubylith, for art that is to be silhouetted (Fig. 31), another may simply request a tissue overlay indicating the silhouette.

It isn't just the printing technology that is changing. Improved computer design programs and finer-resolution computer printers are transforming the very form in which material is presented to the printer. This book, for example, was written, typeset, and laid out on a computer. Much of the art was also generated on the computer, and it was run out in page form (already positioned), making the preparation of film much easier.

Although computers are assuming more and more of a role in the whole design process, it is still important for designers to understand traditional mechanical techniques. Many jobs still require some pasteup work, even if this is combined with computer output.

31 Art with Rubylith overlay

32 Separate mechanical for black plate showing Rubylith for solid black area

33 Separate mechanical for color plate showing red keyline for tint areas

34 Printed result

TRADITIONAL MECHANICAL AND ART PREPARATION

In preparing mechanicals for two-color printing, some designers still preseparate everything, putting anything that will print in the second color on a separate acetate overlay, with the black copy on the base mechanical (Figs. 32–34). Before you do this, check with the printer or the person doing the camera work. Although sometimes it is significantly more expensive if you don't preseparate the art, in many instances preseparating is entirely unnecessary. In general, as long as the elements that are to appear in the different colors do not overlap, they should both be put on the same mechanical (Fig. 35). Then you can simply indicate on a tissue overlay or the mechanical itself what should print in the second color, as well as any elements that should be screened. (Note that some printers expect all instructions to be written on the board and will throw away any covering tissue; be sure to ask which system your printer prefers.)

Even if one color surprints another—for example, if you want black type in a box that's a tint of the second color—you may not need to prepare a mask for this area. Ask your printer. You may be able to just outline the area (in red or black), creating what is called a keyline, or holding line; then indicate on the mechanical or tissue overlay that the area within the keyline prints a certain percentage of color but the keyline itself does not print (Figs. 36–37).

A keyline may also be all that you need to indicate two color areas that abut at a clearly defined edge. Draw this line clearly with black or red ink as it becomes the trap for the printer (the area where the two colors will overlap, so no white shows in between). And don't forget to note that the keyline does not print.

In all these instances placing the elements on the same mechanical board is not only much easier for the pasteup artist; it also generally makes it easier for the printer to keep the different elements in register.

What about halftones? If, for example, you want type to either surprint or drop out of a halftone, you may not need to put the type on an overlay, since the halftone will be shot separately anyway. Ask your printer. You may simply be

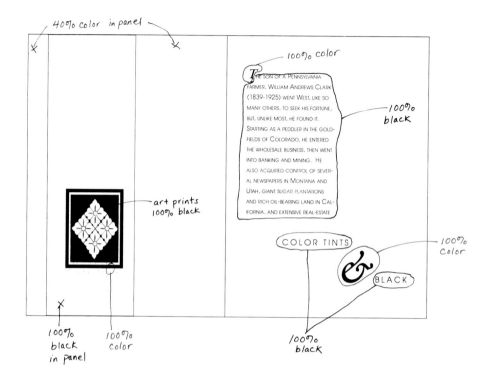

35 Single mechanical for both plates of Figure 34

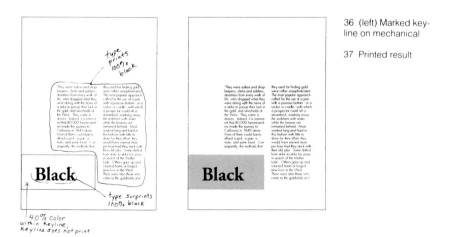

36 (left) Marked key-
line on mechanical

37 Printed result

(handwritten notes) 100% color in keyline — keyline does not print

X —

(body text within figure, small type) built fortunes by supplying the prospectors with badly needed goods and services. Among them was a German immigrant who came to San Francisco with a large supply of canvas which he planned to sell to the miners for tents. When he arrived in the goldfields, however, he found that they needed pants more than shelter, because panning for gold in the rugged terrain had worn out their trousers at the knees. So he used his canvas to make pants, switching to denim when his material ran out. His name was Levi Strauss. And the pants he developed? They became a worldwide phenomenon called blue jeans. They were sailors and shop-

keepers, clerks and soldiers, dreamers from every walk of life, who dropped what they were doing with the news of a strike to pursue their luck in the gold and silverfields of the West. They came in droves. Indeed, it is estimated that 80,000 fortune-seekers made the journey to California in 1849 alone. Most of them could barely afford a pick, a pan, a mule, and some food. Consequently, the methods that they used for finding gold were rather unsophisticated. The most popular approach called for the use of a pan

— type 100% black

38 Base mechanical for middle figure on page 37

Color

— 30% color — knocks out of panel

39 Overlay for overlapping color area in same figure

40 Position stat or photocopy

able to place a photostat in position and paste up the type directly on top, with appropriate instructions on the board or a tissue.

If, on the other hand, you want the type to surprint or drop out of a line conversion, you should place the type on an acetate overlay. The appropriate instructions can then be given on the main mechanical board (e.g., "Knock out type on overlay"), on a piece of masking tape at the edge of the overlay, or on a covering tissue. It is not necessary—or even desirable—for you to actually reverse the type and paste up a negative stat in this instance; leave that operation for the printer. Make sure, however, that you include two registration marks on both the acetate overlay and the main mechanical board so that the printer will align everything exactly the way you want it.

Another instance when you should use an acetate overlay is if a design element overlaps two different color areas. In Figures 38–39, for example, where the type overlaps the color and white areas, the type must be placed on an overlay. Similarly, in the graphs on page 38, the columns were put on an overlay, while the background color and graph lines were placed on the main mechanical board. If the color breaks are complicated, you may want to supplement the instructions on the mechanical with a small color sketch.

The best way to indicate halftones on a mechanical is by pasting a photostat down in position and marking it FPO ("for position only"). Key the stat by number or letter to the photograph. Although many designers now use photocopies instead of stats, be aware that photocopying machines are not always precise—an image copied at 100%, for example, may actually be one or two percentage points off. Whether you use a stat or a photocopy, if its edge happens to be dark on all four sides, there is no need for a keyline. If, however, one or more edges are light (and thus likely to be lost on the printer's film), draw a keyline guide, indicating the full image size. Then trim the stat or photocopy, cutting each side in a wavy line (Fig. 40). This wavy line is usually sufficient to inform the printer that the image fills the indicated area and that the keyline (or holding line) does not print. Ask your printer, though, to be sure. Some printers prefer that you add the instructions: "Image fills area; keyline does not print."

Another way to indicate a halftone is by using a keyline to mark the edges of the image and writing a photo identification number within that area. The disadvantage here is that, without an easy visual reference on the mechanical, the printer is more likely to mix up images, flop the art, strip it in upside down, or crop the image incorrectly. Of course, these errors can occur even with the best-prepared mechanicals, but you reduce the risk with FPO stats. A good compromise is to place a greatly reduced photocopy (much smaller than the image size you want) within the keyline and indicate the scale on the original photograph. The photocopy can then show how the photograph should be cropped, in addition to serving as a visual identification.

Finally, there is the traditional method of indicating halftones by cutting a Rubylith as a window for the image area. This method, however, is no longer recommended; in fact, for some printers, this use of a Rubylith is more of a hindrance than a help.

The photographs themselves should be tagged (Fig. 41) with the name of the job (or the client's name), an identifying number or letter (also indicate the page in a brochure, report, book, or magazine), the percentage the image should be enlarged or reduced, and what kind of halftone is needed (square, dropout, ghost, duotone, and so on). If the image is a duotone, be clear about the effect you want. You might, for example, note: "Use color to bring out detail in shadows," or "Put a little color in highlights." It is best to tape a tissue overlay on all photographs for protection. If you want to crop or silhouette an image, you can indicate this on the tissue. (Check with your printer, however; some prefer that you put the crop marks in the white margins of the photograph.) Obviously, any writing on the tissue should be done with a felt pen and with a minimum of pressure to prevent damage to the photograph.

If you plan to have callouts or labels on the art that must go in a precise location—such as a particular tooth in a photograph accompanying an article on dentistry—it is best to place the callouts or labels on an overlay to the art itself rather than on an FPO stat on the mechanical. Keep in mind, however, that if you reduce or enlarge the photograph the type will also be reduced or enlarged—so size both accordingly. Another caution: when reducing a callout

CLIENT / JOB: _____

FIGURE NO: _____

PAGE NO: _____

FINAL SIZE: _____

FOCUS: _____

COMMENTS: _____

41 Photo tag

line or type, make sure that the reduction remains thick enough to print.

One final word of advice on preparing mechanicals. Whether you convey your instructions to the printer on a tissue overlay or write directly on the mechanical, it is crucial that you communicate clearly. Directions should be brief and to the point: "Type prints 80% process blue" (with the type circled and linked to the instruction). And make sure your handwriting is legible; it's worth the effort to spend a few extra minutes writing your directions neatly so there's no question about what you want. (One designer with illegible handwriting even types her instructions.) Also erase any extraneous remarks on the tissue or mechanical, such as an editor's indication that a certain word should be in italics—comments like this will only confuse the printer.

PREPARING COPY ON THE COMPUTER

As already noted, computer technology can be used in different ways to prepare material for the printer. The text can be set and pages designed on the computer. Keylines can also be drawn in position on the page with the computer—relieving the pasteup artist from a tedious, time-consuming task and ensuring accuracy. This information can then be output as reproduction copy and placed on a mechanical board, with photostats positioned within the keylines and overlays prepared as needed.

2

CHOOSING THE
SECOND COLOR

To make effective color choices, you need to know how color works—how we see color. Of course, a whole book could be written on the subject of color (and quite a few already have been). For the designer working in two colors, however, there are only a few basic points to remember.

The most important thing to understand is that we never see color in a vacuum; we perceive color in relation to other colors, in an environment. When you choose a second color you must first envision how that color will interact with the rest of your design. As Josef Albers clearly demonstrates in his book *Interaction of Color*, the same color can look different when placed on different backgrounds, and different colors can look the same when influenced by the background color. In other words, a small red square printed on a sheet of white paper will appear to be a different color from a large square printed with the same red ink (Fig. 42; see also Fig. 43). The real issue, then, is not so much which color you choose, but what you do with it, how you use it in your design.

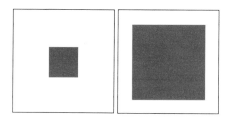

42 Effect of size on color perception

43 Same red knocked out from 20% black (left) and 60% black

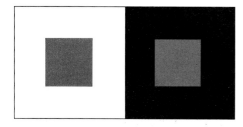

44 Illusion of value difference with same red

45 Pure red (left) versus red plus 20% black (less intense although darker)

BASIC COLOR PRINCIPLES

To understand how color works, it's helpful to look at some basic color properties. There is a big caveat here, however: it doesn't matter how fluent you are with color terminology; what counts is your ability to get the visual effects you want.

The first color term you are likely to encounter is *hue*, which is defined as the attribute connected with a color name—red, blue, green, and so on. More simply put, hue is what you think of when someone says "red"; it's the essence of redness.

Another way to describe color is in terms of its *value*—its lightness or darkness. The principle is simple: adding black darkens a color; adding white lightens it. In printing, you can screen a color over black to darken it or screen it over the white paper to lighten it. Value can have a dramatic effect on how color is seen. A red square on a white background will look darker than a red square (of the same size) on a black background (Fig. 44). In general, the same color looks darker on a light background and lighter on a dark background.

Value may well be the most important color characteristic in design. A change in value can drastically alter the impact of a design. Fortunately, most clients react more to hue than to value. A change in hue will not affect the design as much—as long as you maintain the value.

A third reference point is *chroma*, or intensity, which describes a color's saturation, or purity. Adding black or gray (a percentage of black) dulls a color (Fig. 45). Mixing a hue with white also decreases its chroma. Although any mixture of two hues reduces saturation, combining complementary colors—red and green, blue and orange, yellow and violet—grays the color most.

Related to chroma is the choice of a *clean* or *dirty* color. Clean colors are pure hues—without admixtures of black or white—such as rubine or warm red, or reflex or process blue. Dirty colors contain a bit of the complementary color or some black—muddying the color, so to speak. In terms of printing, the important point is that while clean colors look great full strength, they usually do not work well in tints, turning into weak pastels. Moreover, in areas of type

clean colors can become shimmery, especially if they are offset by a bright white background. The effect may be dazzling, but the type is hard to read (Fig. 46). To avoid these pitfalls, you might combine the color tint with a black tint to give it backbone. Or you may prefer to use a dirty color. Although dirty colors are not as bright as clean ones, they offer more flexibility in tints—working both on their own and in combination with black. If the piece contains duotones, you'll almost certainly want a dirty color rather than a clean one (compare page 51 top with page 123 top). An additional advantage of dirty colors is that they can be used effectively for type, even in quite light values.

Another important color characteristic is *color temperature*. Red, orange, and yellow are generally considered warm colors, while blue, green, and purple are regarded as cool. Warmth and coolness, however, are relative terms. Although red is almost automatically called "hot," a bluish red may be cool compared with an orange-red. Generally, the more red a color mixture contains the hotter it is; the more blue, the cooler it is. Keep in mind that the black ink you use may be warmer or cooler, redder or bluer, and the same is true for white paper. Both will affect the other color you choose.

Color temperature leads into the principle of *advancing* and *receding* colors, which can be an important design element. Generally warm colors advance, coming forward toward the viewer, while cool colors recede. Chroma also affects color distance, with brighter colors reading forward and less intense ones lying further back. Value is another aspect to consider here. A bright light color tends to advance, while darker colors stay back in the shadows. The amount of color is yet another variable. Look at Figure 47. The larger color area tends to read as background with the smaller color area lying on top—although, with the right proportions, there can be a push-pull reversal, in which the small area is read as a hole in the large area (and thus further back).

Yet another consideration is *color contrast*. Even with just one color and black on white, some pairings offer more contrast than others. This is especially important with type, where legibility is an issue (Fig. 48). A dark blue on black or pale yellow on white may be hard to read because of the

46 Pure color interfering with readability

47 Advancing and receding color

48 Variations in legibility

lack of contrast. Even a bright blue on black or a bright yellow on white would be hard to read. Instead, you might try the blue on white or the yellow on black.

COLOR ASSOCIATIONS

Essays and even books have been written about the psychological impact of different hues. But there are no clear-cut rules. And it's important not to let the various theories about a color's meaning inhibit your creativity in choosing a color. After all, associations differ from person to person and from theorist to theorist. Moreover, the associations triggered depend a lot on the design. It is design that is really critical in the impact of a piece. Select the color that works best in your design.

Still, it can be fun to at least consider some common color associations. Imagine that you are designing a brochure for an accounting firm. You might want to avoid red, which can connote debt or be linked with anger. Instead, green with its association to money, growth, and vitality might carry a psychological advantage. On the other hand, you might play on red to demonstrate the red-hot tips the accounting firm has to offer, or go with a less obvious choice like yellow to suggest richness and hope—or maybe enlightenment.

Being aware of color associations may also help to avoid a reading you don't want. If you're working on a promotion piece for a particular product, for example, you'll probably want to stay away from a competitor's corporate colors so there's no confusion in the consumer's mind—although, of course, there are designs that exploit this confusion (just take a look at some of the product packaging in supermarkets). In any case, the visual effectiveness of a color should always be your number one criterion. If red is the color that gives an accountant's brochure the most punch, then go with it, despite its associations.

3

PRODUCTION
CONSIDERATIONS

Even if you know how to take advantage of two-color techniques and how to make color work well in your design, you still must consider certain production variables, which can have a major effect on the appearance of a piece. Obviously, it is important to have a good printer, for without care at the printing stage, even the best-designed piece can lose its appeal. Printing is an art in itself, requiring skill to produce top-quality results. In addition, a good printer can be an invaluable adviser, answering any questions you may have about how a particular design idea will work on press. Some design decisions, such as opting for large areas of solid color, can create problems on press. A good printer may suggest ways of minimizing the problem and will take extra care on press.

Although designers don't need to know all the ins and outs of printing, they should be aware of the most common problem areas and what to look for on press. In addition, designers should understand the basic choices involved with paper and printing inks. Your printer, of course, can

advise you on what will work best for a particular job and also fit within the budget. But the more you know about the choices, the better able you will be to evaluate this advice.

PRINTING INKS

Most designers in the United States use the PANTONE® MATCHING SYSTEM to select their second color. This system was developed during the l960s to facilitate communication between designers and printers. "The PANTONE Color Formula Guide 747XR" provides ink formulas for approximately 750 colors, using combinations of the nine PANTONE Basic Colors, PANTONE Transparent White, and PANTONE Black. With experience, just knowing the formula can help you predict how tints of a color will look. Also, by noting the PANTONE Number and supplying a swatch of this color on the mechanical, you refer the printer to PANTONE's mixing instructions, so the printer knows exactly how to make the color you want.

Even with this system, however, there may be variations in the color selected and the color that appears on press. First of all, designers should be aware that the "PANTONE Color Specifier 747XR" (from which you can tear out a chip of the color you want) has only about a year before colors begin to fade slightly. Then, there is the paper to consider. Although the "PANTONE Color Specifier 747XR" shows samples on coated and uncoated stock, this is only a broad division of paper differences. Both coated and uncoated papers come in different finishes (see page 29), which affect the absorption of ink and thus the color's vibrancy. In addition, the white of the paper may be different, depending on the mill—and this, too, affects the way the ink prints.

One way to check all this is to ask for a "drawdown"— where the printer prints an ink sample on a sheet of the paper you intend to use. (Printers used to put the ink on a thumb and draw the thumb down until the ink thinned out—hence the term "drawdown.") But even a drawdown is not an exact prediction of what will happen on press, where the ink density may not be the same (see page 31).

You should also be aware that certain colors have certain limitations. Blues, for example, tend to be light-sensitive

and thus may fade over time. Ink formulas that contain opaque white may also present problems; they tend to streak on press and may not cover well.

If your design features art photos, you may want to specify the black (warm or cool) as well as the second color. Another option is to select a very dark color that reads as a black, such as PANTONE 532 (a dark blue containing a lot of black). When you screen this color, you will get slightly bluish tones rather than neutral grays. The "black," however, may not be quite as dense as a true black.

Although we've emphasized the PANTONE MATCHING SYSTEM in this discussion, there are other color-matching systems in use. The main alternative in the United States is Toyo, which offers many more subtle variations in its inks. However, only a few printers have these inks.

PAPER CHOICES

For brilliant, accurate color printing, you need a balanced white paper with high reflectance. If the paper is slightly dull, the color will be correspondingly dull. Similarly, if you use a bluish, yellowish, or pinkish white paper, your second color may appear slightly grayed. Moreover, a pure yellow on a bluish paper may turn somewhat green—to give just one example. In halftone reproduction the paper color can be critical, for the paper whiteness determines the brightness of the highlights.

The paper surface is another important variable. First there is the choice between uncoated and coated paper. Uncoated paper tends to absorb more ink and may leave particles of dull pigment on the surface, dulling the image. There may even be a slight loss of detail. In contrast, a coated sheet provides better ink holdout, absorbing just enough of the ink's vehicle to bond the ink to the paper, but leaving enough vehicle on the surface to retain the ink's gloss and thus the color's purity. This is important not only for the brightness of the color but also for the sharpness of the dots in a halftone.

If you must use uncoated stock, you can compensate somewhat for the paper's greater absorbency by using an 85- to 110-line rather than a 150-line screen for halftones.

With a coarser screen (fewer dots per inch), the dots are less likely to run into each other when the ink is absorbed.

Both uncoated and coated papers come in different finishes—rougher or smoother, duller or glossier. A rough texture, which reflects light unevenly, may gray a halftone or solid black area. It may also distort delicate serifs or interfere with small print. Yet a somewhat rough texture, such as an uncoated vellum, may be appropriate for a soft, fuzzy illustration. Obviously, the finish you choose depends a lot on the thrust of the particular piece—not to mention the budget. If top-quality halftone reproduction is the priority, you probably want a smooth, glossy coated sheet. However, if reading is key, you might prefer a dull finish, with less glare and thus less potential for eye fatigue. The "feel" of the paper should also be considered. A smooth, glossy finish would probably be inappropriate for an informal pamphlet on saving money.

Yet another consideration is the paper's opacity or show-through potential. Obviously, if you are printing large areas of a dark solid or halftones back to back, you want a more opaque paper to minimize show-through. A good way to check a sheet's opacity is to put it over a black-and-white pattern—the less you can see, the better! Sometimes, however, a compromise is necessary. Keep in mind that coated papers tend to be less opaque than uncoated papers, so you may need a heavier sheet. Moreover, calendering—the finishing process used to increase paper's smoothness and glossiness—makes the sheet thinner and less opaque. Again, you may need a heavier sheet.

The weight of the paper has some relationship to opacity, and in this way has a bearing on color reproduction: generally, the greater the weight, the greater the opacity. However, the other paper variables—size, bulk, and grain—have little effect on the reproduction of color per se, although they do affect design.

PRE-PRESS PROOFS

Your first chance to check the printing quality comes with the pre-press proofs. For two-color work, blueprints (or "blues") are the most common and least expensive type of

proof. They are made from "flats" (the sheets on which the film for both the image and type areas is stripped into position prior to platemaking) and thus allow you to check that all the design elements are correctly placed. Look at these proofs carefully: if an aspect of the design isn't working, now is the time to fix it—not when you go on press.

One of the first things to check is that everything is positioned correctly. If the piece has several pages, make sure they are in the correct sequence. Examine all the art to make sure that the images are the right size and correctly cropped and that none are flopped (reversed) or upside down. Also check the sharpness: are all the details clear? With duotones and other two-color areas, look out for any fuzziness or blurring caused by faulty registration (see Fig. 49 for an example).

Pay special attention to the color breaks. Although the blues are all one color, there is usually a tonal difference that indicates the second color. If you are not sure that a color break has been made, ask the printer to double-check. Keep an eye out for type or other design elements that have been mistakenly masked out by the printer. Compare the proof against the original mechanical to make sure all the elements are intact. Finally, look for spots or scratches, broken type, and breaks in screened areas.

It is also possible to receive a Color Key, where each color is shown on a separate overlay. This proof allows you to see the color breaks quite clearly. It is not, however, a proof of the actual color, as only a few standard colors are used in Color Keys. To check the color, you must have press proofs (run on a small hand press) made. Few domestic suppliers are set up to do press proofs, which means that the only time you can check the color is on press.

49 Faulty registration

PROBLEMS ON PRESS

As already noted, the final effect of a design depends on the printing. All the decisions about design, color, screens, halftones or duotones, printing inks, and paper come together on press. Although pre-press proofs give you an idea of how everything will fit together, they are often printed on different paper and under different press condi-

tions. The only way to make sure you get what you want is to be on press.

The appearance of the second color, for example, can change significantly in printing. The main factor here is the ink density. If there is too much ink, the color may look darker—a purple, for example, may seem black. Type may also appear fatter and fuzzier. Too little ink can result in a namby-pamby hue. Images will look washed out and the type may become thinner.

Printing a large area of solid color is particularly problematic as even coverage is difficult. Watch out for streaking and washed-out areas.

Tints present a different kind of problem. In areas that are screened there will be a certain amount of dot gain on press (the dots actually become larger during printing). For example, a 20% black tint may look like 25% on press. Dot gain can also present a problem with halftones and duotones, causing a loss of clarity or detail. Dot gain is particularly likely to occur on more absorbent papers, especially uncoated sheets; it may also be caused by press conditions. Modern technology is making dot gain less of a problem, but ask your printer what to expect on press.

Keeping tints consistent from page to page poses a challenge to the printer. Usually you can expect some fluctuation, but the degree of consistency depends largely on the quality of the printing job.

With halftones and duotones, a good printing job can make an enormous difference. The order in which the plates are printed can be important with duotones. The printer usually decides which plate to run first, but if the image seems dead, without sufficient contrast, you might question the sequence.

There are other, general problems to look for on press. Start by making sure the registration is correct wherever something is surprinted or knocked out and trapped. Also keep an eye out for doubling, caused by a slight second contact of the paper with the offset blanket. Ghosting is another potential problem, in which a faint image is offset from one area to another. You might, for example, see the ghost of a circle shape from the previous page within the design of the page you're looking at. This is most likely to happen with large areas of solid color.

Hickeys, imperfections caused by specks of dust or dirt, are a common problem. Look particularly carefully for spots within type areas and artwork, where hickeys may not stand out immediately. Also check for smudges and scumming (when ink appears in nonimage areas, where only the paper should show).

In addition to checking for specific problems, look at how everything is working together. Does the color balance seem right? Is there good contrast throughout? Also keep in mind that a press sheet, where the ink is still wet, will look slightly different when it dries. On uncoated paper, for example, the ink may appear lighter when it dries.

Overall, what counts on press is your ability to work with your printer. Some compromise may be necessary—a tiny, almost invisible speck of dust, for example, may not be worth correcting, while other errors may be critical. Understand the printer's limitations and work toward the best possible results.

4

USING WARM DIRTY
COLORS

T
wo of the most important questions to ask in choosing a second color are (1) do you want a warm or a cool color? and (2) should it be clean or dirty? Warmth and coolness have different associations. Usually, for example, warm colors are preferred for pictures of people, while cool colors are favored for industrial scenes. In general, the second color's warmth or coolness helps to set the overall tone, although, of course, a lot depends on the design.

The choice of a clean or dirty color is largely based on how you intend to use the color. A clean, or pure, color offers brightness and an immediate visual punch. Although a dirty color, which contains some black, is less intense, it is more versatile, working well both full strength and in tints. It can also be used for fairly small type in ways a clean color cannot.

This chapter and the three that follow allow you to compare the effects of warm or cool, clean or dirty colors on the same image. The color in this section is made up of 14 parts yellow, 2 parts rubine red (a cool red), and $^1/_4$ part black. With this small amount of black, you have the benefits of a dirty color, while retaining much of the colorfulness of a pure hue.

PAGE DESIGNS 1

In these examples the second color is used primarily as a design element, with only an occasional editorial function. It may demarcate paragraph breaks, as in the top example, or draw attention to the start of a new section, as in the bottom example—but its main job is to enliven the page, making the text more inviting to the reader.

The three designs all show the use of simple solids in page layout. As indicated on page 8, this is the easiest choice you can make in terms of preparing the mechanicals. No overlays are necessary. Even in the middle and bottom layouts, where type is dropped out from a color area, all that is needed is a keyline for the color area (with the type in position within it) and instructions to print 100% color within the box and to knock out the type to white. (The mechanical is similar to Figure 36 on page 18.)

To see just how much the second color enhances the design, make a black-and-white photocopy of this page (or the version on page 66, which reproduces better) and compare it. With only a few touches of color, you can add considerably to the excitement of a design.

USING COLOR

At the outset of the 19th century, the nation's leaders expected that it would take 500 years to settle the West. Instead, the 1890 census declared the frontier closed. What made the difference, more than any other single factor, was the railroad.

Spurred on by Congress and the state legislatures - which provided more than $64 million in bonds and 116 million acres in land grants - the railroad companies went from 3,200 miles of short-line track west of the Mississippi in 1865 to 72,000 miles by 1890. When the Railroad Act of 1862 called for the creation of a transcontinental railroad, the Union Pacific started west from Omaha, Nebraska, while the Central Pacific started east from Sacramento, California. Crossing two mountain chains - the Rockies and the Sierra Nevadas - and the Great Basin, with its inadequate supplies.

USING COLOR

Wood and water, they laid an average of two to five miles of track per day. On May 10, 1869, they met at Promontory Summit, Utah and the nation was linked by rail. During the ensuing year, 150,000 passengers made the journey between Omaha and Sacramento. A decade later, the figure approached 1 million. "A journey over the plains was a formidable undertaking, requiring great patience and endurance" reported Frank Leslie's Illustrated Newspaper. "Now all that has changed. . . the six months' journey is reduced to less than a week." And thus the way for people to come West had been eased, and the heavy flow of goods between the frontier and the rest of the nation had begun.

At the outset of the 19th century, the nation's leaders expected that it would take 500 years to settle the West. Instead, the 1890 census declared the frontier closed. What made the dif-

PAGE DESIGNS 2

These layouts make use of both solids and tints, giving a greater feeling of color to the page. The mechanical preparation is still relatively simple, as the color areas are for the most part discrete.

For the first example, only one board is needed. The tint panels (printed in 40% color) can be indicated by a keyline. Within the panels, everything is separate; there are no overlapping areas. The elements in either solid color or 100% black are simply marked to surprint, with the white area knocked out.

The second example shows how a dirty color, which contains some black, can be used for type and remain readable. Note, however, that the type should be a heavy weight, at least semibold. Almost all the elements can be placed on the same mechanical. In the one area of overlap, however, the oval (printed in 20% color) must be placed on an overlay to separate it from the black doodle.

In the last example, the oval is 40% black surprinted on a background of 60% color. Here everything can be placed on the same board except for the oval, which overlaps the color area. The doodle line must then be knocked out of the oval before being printed in solid color.

The picture above is framed in color and printed in black but dropped out of the background tint.

As people began to populate the West, they hungered for news of home. Just as importantly, events were taking place on the frontier - such as the discovery of gold in California - that were of interest to the people back East. To facilitate communication between the coasts, Congress created an overland mail service in 1857, reducing by more than 50 percent the time that it took to carry a letter from St. Louis to San Francisco (from about two months to about three weeks). Then came the celebrated Pony Express, which offered ten-day service from St. Joseph, Missouri, to San Francisco. Wiry lads of 18 years or younger galloped all the way, changing mounts every 12 to 15 miles (it took 75 horses for the entire journey). It was difficult and dangerous work, but the Pony Express riders were among the West's most celebrated heroes. Then, in October 1861, the service became obsolete - the transcontinental telegraph had been completed. Still, it took years for telegraph wires to cover the vast expanse of the frontier. In 1876 there were only 3,000 miles of line in the entire nation; by 1900 there were 1.4 million. Businessmen used the new technology to a greater degree than

the average citizen - the wealthiest even maintained ticker tapes in their offices so they could follow fluctuations in the stock market - but the average person could - and did - send telegrams as the occasion warranted.

A more personal form of communication arrived with the advent of the telephone. As with the telegraph, it took time for the new technology to make a difference in the lives of the average Westerner, but, by as early as the mid-1880s, switchboards were cropping up here and there. The terrible isolation borne by so many frontier families had come to an end. As people began to populate the West, they hungered for news of home.

Just as importantly, events were taking place on the frontier - such as the discovery of gold in California - that were of interest to the people back East. To facilitate communication between the coasts, Congress created an overland mail service in 1857, reducing by more than 50 percent the time that it took to carry a letter from St. Louis to San Francisco (from about two months to about three weeks). Then came the celebrated Pony Express, which offered ten-day

This text is printed in black but the initial surprints the tint in color.

The son of a Pennsylvania farmer, William Andrews Clark (1839-1925) went West, like so many others, to seek his fortune, but, unlike most, he found it. Starting as a peddler in the goldfields of Colorado, he entered the wholesale business, then went into banking and mining. He also acquired control of several newspapers in Montana and Utah, giant sugar plantations and rich oil-bearing land in California, and extensive real-estate holdings. He created the first water company in Butte, Montana, the first electric light company, and one of the first trolley car companies. In 1884, he decided to create a mansion befitting his station as one of the nation's wealthiest men. Three years later, the three-story, 30-room home designed in the Renaissance revival style by Los Angeles architect C. H. Brown was completed. It cost approximately $280,000 at a time when Clark's estimated earnings came to $17 million a month!

European craftsmen handcarved woodwork throughout the house and frescoed the ceiling of every room of the first two floors. The mansion boasted a 62-foot-long ballroom, stained glass windows by Louis Comfort Tiffany, fixtures fitted for incandescent lighting as well as gas, and an impressive main staircase with intricately carved panels of birds and flowers from various countries of the world. The latter, called "The Staircase of Nations," was removed from the house in 1903 and exhibited at the St. Louis World's Fair. Eventually, when Clark became a U.S. Senator, he erected a 121-room mansion in New York City. That structure was torn down, at his request, upon his death, but his home in Butte survived. The oldest mansion in Montana, it is privately owned by Mrs. Ann Cote Smith, who lovingly restored the home with

Wilson liked to portray them as stalwart champions of justice. Bat Masterson called them ordinary men "who could shoot straight and had the most utter courage and perfect nerve - and, for the most part, a keen sense of right and wrong." But neither Hollywood nor Masterson caught the true measure of the law enforcement officer, for more often than not he was a shady character, one who

PAGE DESIGNS 3

The second color can be used to add drama to a page design, as in the first example here. With such a large area of solid color, it is usually best to use a dirty color, which will not jump out and dazzle the viewer as much as a clean color would. Most important, be sure the other elements on the page can hold their own against a solid border. If, for example, the image on the right were printed in a light tint of color, it would be overwhelmed by the full-strength color around it.

Printing type in a solid color on a tint of the same color, as in the second example, can add interest to a page—if there is sufficient contrast between the tint and the full-strength color. Because clean colors often become weak pastels in tints, a dirty color is usually preferable for such a large tint area. In this design the dropout in the square on the left suggests another spatial level, increasing the liveliness of the page. The 60% black "C," which surprints the 30% color tint, brings in yet another dimension.

The third layout clearly shows the visual power of a few simple elements. As in the top example, there are no tints—only solids. Here, however, it is necessary to preseparate the black panel from the orange "S," so that the "S" can be dropped out of the panel before being printed. It doesn't really matter whether you put the "S" or the panel on an overlay—as long as you do one or the other.

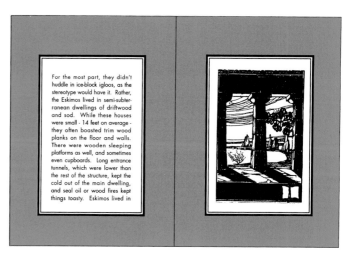

PAGE DESIGNS 4

The variety possible in two-color page design is limited only by the designer's imagination. The layouts here are still relatively simple, using at most one tint of color. Keep in mind that each additional screen you request will usually add to the cost. Although the increased charge may not be much per page, if you have multiple screens throughout a job, the total can be an unpleasant surprise.

The first example has a lot of visual movement, with the back-and-forth pull of the full-strength color and black against the pale (20%) tint of color. Notice how important the small white area becomes in attracting attention to the illustration. The mechanical here is simple to prepare, essentially following Figure 35 on page 18.

The middle layout is a good example of how color contrast can affect the way you read a page. Compare the word "Black," which leaps forward, with "Color," where the contrast is much softer. This difference may be exactly what you want, or you may prefer to use a tint for "Black" to give the two areas equal weight. Although the design is simple, the mechanical does require an overlay for the word "Color," as shown in Figure 39 on page 19.

The final layout indicates how white can have a strong presence as a third color in the design. The dropped-out type reads clearly against the gray (70% black). The solid orange works well in the large quotation marks, although it would not offer sufficient contrast for the text to be legible.

BAR GRAPHS 1

Even a simple bar graph can be presented in many different ways with a second color. In the examples in this section the two colors function editorially only in the sense that they distinguish one element from another. A more complicated bar graph might also use different colors and tints to represent specific kinds of information, such as number of cars produced versus number of cars sold.

The graphs on this page use only solids. The paired examples show the different effect if the horizontal rules are placed in front of or behind the vertical bars. Because in general it is the bar that carries the more important information, it is usually placed in the foreground, where it is easier to read. Note, in particular, the wobbly outline of the bars in the right examples, which make it difficult to see the bars as a whole.

Because the rules and bars overlap, the two elements must be separated on the mechanical —with, for example, the rules and border placed on the base mechanical and the bars on an overlay. The same mechanical is used for all the variations in this section; only the color breaks change. In marking the mechanical, it is important to note if the bars knock out the rules or vice versa.

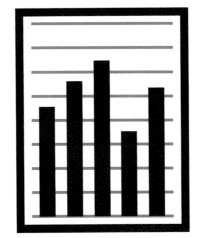
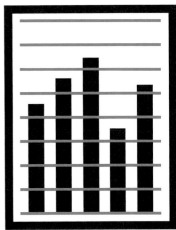

BAR GRAPHS 2

The first three graphs on this page show additional possibilities using only solids. Here the white of the paper acts as a color in its own right. Notice also the different effect when the border disappears, merging with the background.

The other examples on this page combine one screen with areas of solid color. In the middle and bottom graphs on the right the gray is 60% black; in the bottom left graph the tint is 60% color. The only thing that differs in preparing the mechanical is the marking of the color breaks.

The two graphs with 60% black are good examples of the importance of color relationships in our perception of tone. At first glance the gray bars of the graph on the middle right seem darker than the gray rules of the graph directly below it. This perception is based on the relative amounts of gray and white. The background white dominates the rules in the bottom example, while the gray bars dominate in the middle graph.

BAR GRAPHS 3

The graphs on this page show several more possibilities if you use just one tint with solids. All these tints are either 60% color or 60% black. Note the differences in your perception of the same tint in different configurations —particularly in the 60% color background in the graph on the top right and the graph on the middle left.

The top right graph also illustrates a disturbing optical illusion that may arise with certain arrangements. The rules seem to vary in tone, appearing lighter over the black bars and darker over the tint background. Another problem to watch for is imperfect trapping. In this graph the rules are knocked out of the black bars and then printed in solid color. If the registration is not exact, there will be a thin white line along one side.

The permutations shown here are just a beginning. Using one tint—either the 60% color or the 60% black—and the three solids (black, orange, and white) there are at least 25 possible arrangements, not including the 9 shown for the solids alone. Realizing just how many choices there are can be important if limiting your design to one screen plus solids is a budgetary necessity. You don't have to feel restricted.

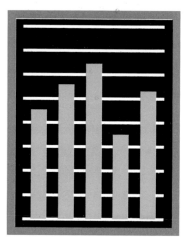
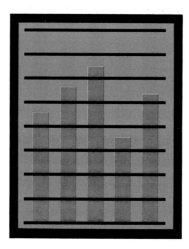
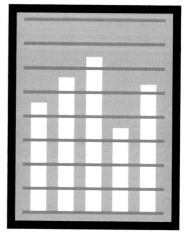

BAR GRAPHS 4

These six graphs combine two tints with solids. The top left graph has a 20% color background and 60% black bars, which surprint the background. If you look at the bars through a loupe, you will see that they contain both black and orange dots. The top right graph reverses the colors, using 20% black in the background and 60% color in the bars, which surprint the background. The rules, however, surprint both the bars and the background, creating a different spatial effect.

The middle left graph offers another inversion. Here the rules are 20% black (like the top right background) and the background is 60% color plus 20% black (like the top right bars). However, the gray here and the one at the top right look very different, showing the impact of color relationships. Also note the visual change in the gray as it crosses the white bars—a distracting optical illusion. In the middle right graph the bars actually change color, but visually they seem the same, reading as a transparent overlay. In fact, the bars are 40% black where they surprint the rules, but 40% black plus 60% color where they surprint the background.

At the bottom left the bars are again 40% black, but they are knocked out of the color background and the 40% color rules. The last graph uses color only in the rules. These 20% color rules seem much fainter than the 20% black rules in the middle left graph because there is less contrast with the background.

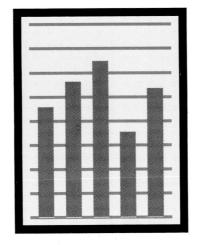
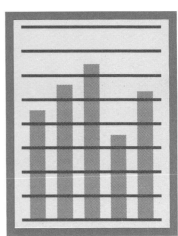
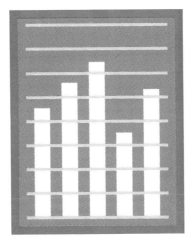
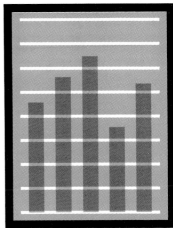
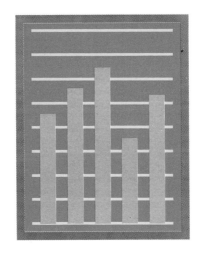

MAPS

With maps, a second color can be used decoratively, as it is on this page, to set off the map as a whole. More frequently, however, a second color is used for content reasons, to distinguish areas with different characteristics. On page 43, for example, color helps to emphasize a particular area. The top map seems more unified as there is less contrast, with the set-off area varying only in value from the rest. The stark black-and-white contrast in the bottom map makes the emphasized area almost jump off the page—which may or may not be what you want.

The maps on page 44 show different ways of grouping areas with two colors. You might, for example, wish to distinguish different time zones or geographical regions (Northeast, Midwest, South). In general it is best to keep the areas fairly close in value so no single area pops out. Both maps on page 44 use combinations of screens to provide color variations while maintaining a relatively even visual weight. The top map seems quiet compared to the bottom map, with its strongly contrasting white outlines and more clearly distinct tints.

On page 45 color is used to show distribution patterns. In the top map, states with similar features—say, the same sales tax—are visually linked by color. In the bottom map, color is combined with pattern to show overlapping distribution. The lightest color might represent states with a low sales tax and the same color with dots states with a low sales tax and a low income tax.

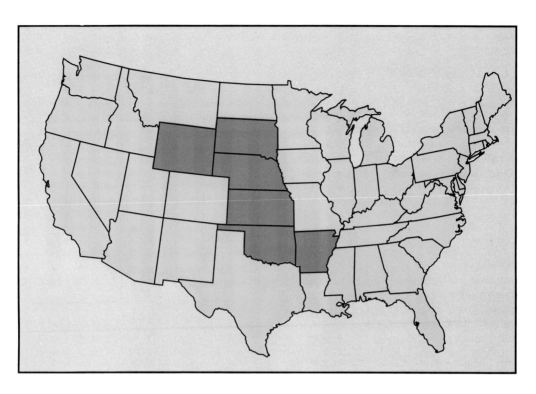

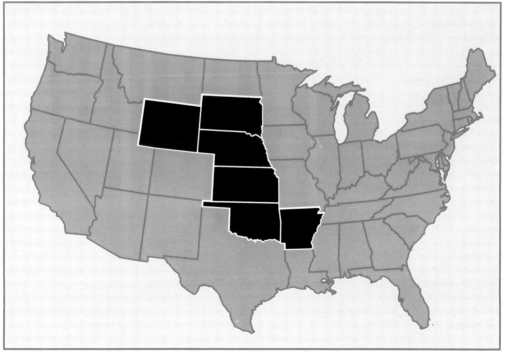

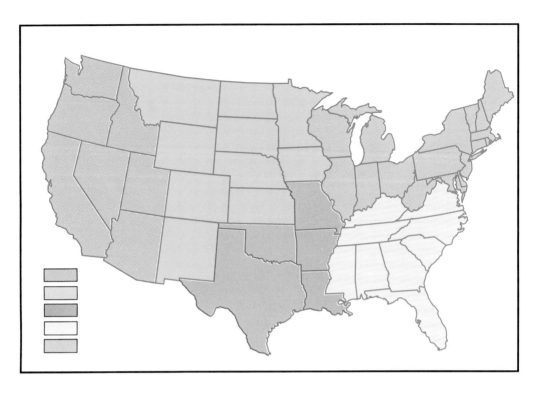

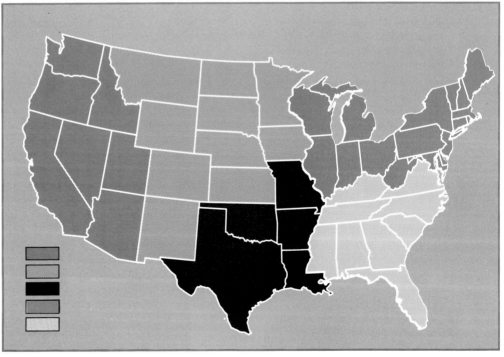

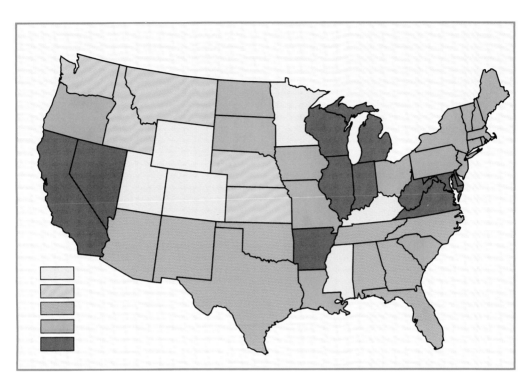

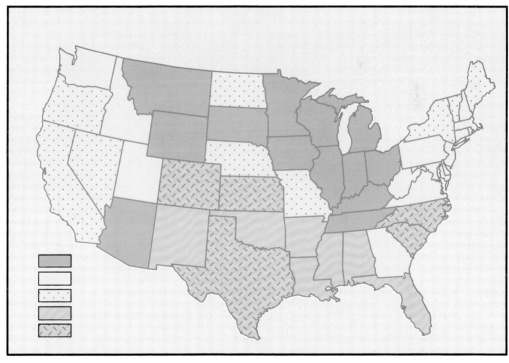

Gasket

Retainer strips

Gasket

Retainer strips

DIAGRAMMATIC ART 1

With instructional drawings, color can be used for emphasis, to make
the rendering realistic, to show perspective, or to distinguish ele-
ments. In the top example, everything is grayed except for the area
being worked on, which is depicted in 20%, 40%, and 100% color.
The retainer strips are also differentiated with two tints of darker gray.
The bottom example offers more realism. The light and dark values
establish the perspective; the orange color suggests wood (and flesh
in the hands), while the gray indicates metal. It may seem that there
are more tints, but actually there are the same number as in the top
example—they are just distributed differently.

A simple line drawing—without any overlays—can serve as a mechan-
ical for both examples, with the tint areas color-keyed on a photocopy.
Preparing the key requires a lot of visualization; it may help to do color
sketches to be sure the perspective works.

DIAGRAMMATIC ART 2

These two versions are the inverse of each other: what prints in black
in one prints in color in the other. A line drawing serves as a base
mechanical, but an overlay is needed for the lines that are knocked
out to white. Although you could preseparate the various screens with
four additional overlays, this isn't necessary as the tint areas are all
discrete. With today's techniques, the printer can create a much better
fit than the best mechanical artist. But there may be an extra charge.

The strong blacks in both these illustrations make them more dramatic
than the versions on page 46. On the whole the top picture, which
directs the eye to the fan, works better than the bottom one, which
lacks a clear focus. Also, in the bottom drawing the gray hands out-
lined in orange are disturbing, running counter to the way we expect
hands to be colored. Although the top drawing on page 46 also has
gray hands, they fade into the large area of gray.

ART WITH LINE AND TONE 1

The mechanical for these illustrations consists of a line drawing and
an overlay with washes that realistically describe the tonal variations in
the objects. In the top version, the line drawing is printed 100% black
and the wash drawing 100% color. In the bottom version, the line
drawing is color and the tonal overlay is black.

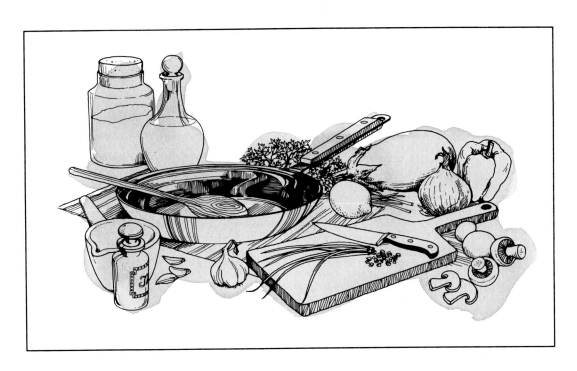

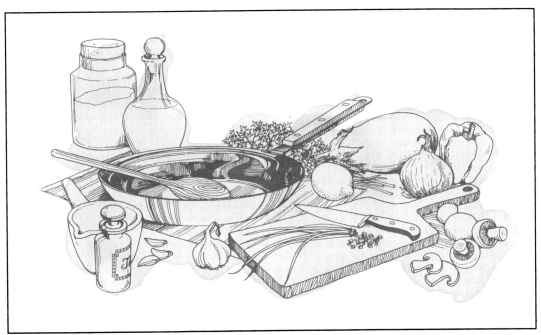

ART WITH LINE AND TONE 2

These two versions use the same line drawing as those on page 48. The overlay, however, is an abstract shape shot as a single (20%) screen of color (top) or black. This is a quick way to give weight and presence to an illustration, without going to the trouble of doing a realistic tonal rendering.

PHOTOGRAPHS OF PEOPLE 1

These three pairs of head shots show the simplest use of color with photographs. All the photographs are reproduced as halftones, in black and white only. In the first pair, the halftone is printed in black over solid color, which flattens the image. Although the halftone is realistic, the color is so unrealistic that the result looks like a mistake.

In the second pair, however, the halftone is printed in black over 30% color, which seems more natural. With the lighter color tint, the black becomes more dominant, so there is a sense of tonal variation. Even with such a light tint, however, there is less contrast than in a halftone on its own (below) or a duotone (page 51) and the overall effect is flatter.

The final pair on this page uses a silhouetted halftone against a full-strength color background. The effect is quite dramatic, throwing the head into relief. For a softer effect, you could use a color tint for the background or a combination of color and black.

The mechanical preparation for this page is easy. You can simply draw the black outlines on the mechanical and provide instructions for the separator on a photocopy. You should also indicate any crop marks, as well as the percentage of enlargement or reduction, on the photographs. For the silhouetted halftone, you may need to prepare a Rubylith (see page 16), or you may only need to outline the silhouette on a tissue overlay.

PHOTOGRAPHS OF PEOPLE 2

These head shots show different duotone possibilities. The first pair uses two normal, mid-range halftones, shot with different screen angles to avoid a moiré. One halftone is printed in black and the other in color. The second pair combines a normal, mid-range halftone printed in black with a flat, low-contrast halftone printed in color. The third pair again uses a black normal, mid-range halftone but this time with a color dropout halftone (where the highlights are dropped out to white). If you look at this last pair through a loupe, you'll see that there are no color dots in the highlights.

All three pairs benefit from the use of a warm dirty color, which suggests flesh tints. Compare these pairs with the silhouetted halftone on the bottom of the preceding page. The contrast seems softened in the duotones, which have a greater range of tones, and the overall tonality is more inviting.

The differences between these duotones are subtle. The middle pair seems the most dimensional, with the clearest definition. The bottom pair, which contains the least amount of color, may seem a bit cooler than the others, but also more dramatic.

PHOTOGRAPHS OF PEOPLE 3

These reproductions reveal just a few of the special effects possible with two colors. In the first pair a normal black halftone is combined with a color posterization. A posterization itself is a combination shot, assembling several line conversions, photographed at different exposures, and in the process simplifying the tones into four groups: black, white, mid-gray, and dark gray. The result here is a more graphic image than the duotones on the preceding page. At the same time the pairing of the posterization with the black halftone yields a more realistic image than a posterization on its own.

The second pair suggests the fun that you can have with two colors and different line screens. A needlepoint-like screen is printed in black, while another type of screen is printed in color. If you look at these images through a loupe, you will be able to distinguish the two different patterns. A variety of line screens are available, from vertical straight or wavy lines to steel-engraving or mezzotint screens. These may be used singly on a color background, combined with a halftone, or combined with each other, as in this example.

The last pair combines two other techniques, a line conversion in color and a solarized halftone in black. The line conversion reduces tonal areas to a linear tracery, while the solarization causes a partial reversal of tones.

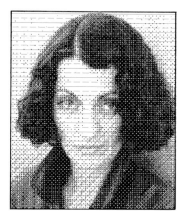
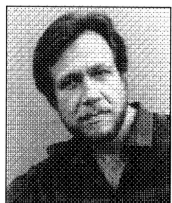
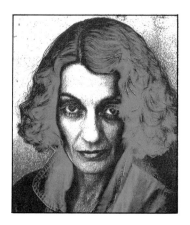
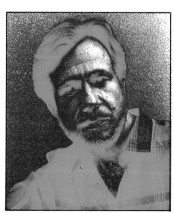

PHOTOGRAPHS OF OBJECTS 1

The photograph in this section is more abstract than the head shots; it also suggests certain industrial imagery. Our expectations of color are therefore different. Here the image is shown on the lower right as a black-and-white halftone. Above, on the left a black normal halftone is printed over 100% color; this seems much more acceptable than it was with the head shots (page 50), because our expectations are different. On the right a color halftone is printed over 30% black. In the lighter areas, where there is less orange, the grays acquire a bluish cast (because blue is the complement of orange).

PHOTOGRAPHS OF OBJECTS 2

The left image combines two mid-range halftones, one printed in
100% black and the other in 100% color. Another possibility would be
to print one halftone 100% black or color and the other a tint of black
or color. With a lesser percentage of color, the black becomes domi-
nant and vice versa, changing the "feel" of the photograph. If you
intend to use a lot of tint variations in a large job, you may want to get
test proofs in advance as a guide.

The right image consists of a normal halftone in color and a more con-
trasty halftone in black, with hardly any dots in the highlights and
much darker blacks. The difference in the resulting duotone is quite
dramatic. In the left image the mid-range halftones had only an 80%
dot pattern in the shadows, lessening the impact of the darks. Half-
tones can be shot in many different ways, so it is important to indicate
the effect you want.

PHOTOGRAPHS OF OBJECTS 3

This image is made up of a dropout halftone in black, with almost no detail in either the highlight or the shadow areas, and a contrasty halftone in color, where there is also relatively little detail in the shadows. The resulting duotone has both darker shadows and brighter highlights than the duotones on the preceding page. Note, for example, the loss of background detail in the top right. Also, looking through a loupe, compare some of the highlight areas.

An interesting aspect of this duotone is the greater sense of color. In the highlight areas, there is no black dot, so the color becomes accentuated, giving a warm glow to the whole. You can see this clearly in the highlighted bands of the tube that opens out to the top right.

PHOTOGRAPHS OF OBJECTS 4

In this image a flat halftone printed in color is paired with a dropout halftone printed in black. The flat halftone of course minimizes contrast, but one might expect the dropout halftone to counterbalance this, defining the forms. In the highlight areas, this is exactly what happens. Look, for example, at the transparent tubes at the middle left, where the glistening highlights articulate the form.

Overall, however, the duotone seems weak, lacking richness in the darks. One reason is that the dropout halftone used here does not provide a full range of darks. It has a lesser percentage of dots in the shadow areas than the dropout halftone used on page 55. The flat halftone compounds this, as by definition it lacks dark darks.

PHOTOGRAPHS OF OBJECTS 5

The left image contains a contrasty line conversion, where almost everything is either pure black or pure white. Because this line conversion is printed in black, it dominates the image, creating a strong graphic effect. The color plate is a flat halftone, with soft tones. The warm color fills all the light areas, where there are no black dots, and the image acquires a delicate pinkish glow.

The second picture reverses the plates, so that the contrasty line conversion prints in color. The flat halftone prints in black, but only 60% black. This time it is the black that colors the image, giving the whole a colder, almost bluish cast. The color line conversion adds emphasis—articulating, for example, the indentations in the two light tubes in front—but the special effect is nowhere near as pronounced as in the first picture.

PHOTOGRAPHS OF OBJECTS 6

These two images make use of a granular, mezzotint-like screen. In the first version the grainy line screen is printed in color over 40% black; in the second example the grainy screen is printed in black over 100% color. The color difference between the resulting images is striking, much like the distinction between the two images on page 53. In fact, a comparison of the two pairs, on page 53 and here, clearly shows what a special-effect screen can add. It may not be a technique you want to use a lot, but it could be highly effective, for example, as a background for dropped-out type.

PHOTOGRAPHS OF OBJECTS 7

Here are two more possibilities achieved with special-effect screens. The first image combines a needlepoint-like screen in black with the same line screen posterized in color for a lively, decorative result. If you choose a combination of line screens like this, it is probably best to consult with the person preparing the film about the effects you can expect.

The other image on this page pairs a solarized halftone in black with a line conversion in color. The result is quite different in impact from the first image. The strong color adds considerably to the strangeness of the result. Without the color, it would not be so dramatic.

PHOTOGRAPHS OF OBJECTS 8

These two ghosted images can be used as backgrounds for type or
another image. The first example is a normal color halftone ghosted to
40% and printed over 10% black. The second example is a normal
black halftone ghosted to 40% and printed over 30% color. As in other
similar reversals in this section, there is a strong temperature differ-
ence between the two images, with the left one appearing bluish to
the warm, pinkish right image. Sometimes it is difficult to predict how a
color will change in a particular situation. There are no hard-and-fast
rules. Knowledge of what to expect comes mostly from experience; an
understanding of color theory may also help.

PHOTOGRAPHS OF OBJECTS 9

This final special effect consists of a line conversion in 100% color printed over 30% black. The image has a grainy presence similar to the left image on page 58, but here there is much more contrast. It's important to remember that whenever a photograph is printed over a screen of color (or black), there will not be any real highlights, which tends to flatten the image. Here, to gain a more dimensional effect, a contrasty image was used for the other plate.

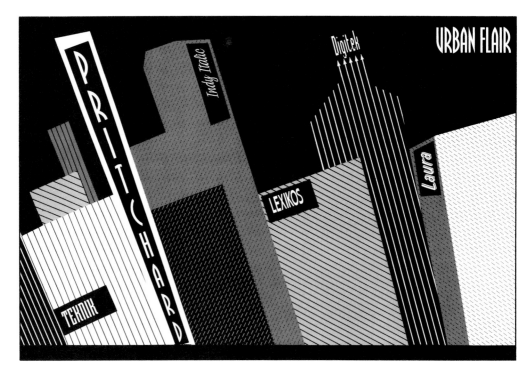

PURE GRAPHIC IMAGES

The design on this page, an advertisement of new Instant Lettering typefaces from Letraset, was originally printed in black. Compare its impact with the two-color versions on the next two pages. Using two colors makes it easier to create different moods, from the drama of the top image on page 63 to the elegant subtlety of the top image on page 64.

The first example on page 63 uses two color tints (30% and 60%) with 100% black. However, the different line patterns and the strong presence of the white paper as a color make it look more varied. The second example is essentially a reverse of the first, with a background of 100% color and tints of 30% and 60% black (there are also areas of 100% black). The color here does not offer as much contrast as the black in the first example, so the result is less dynamic.

On page 64 the top version uses a base of 60% color with tints of 20% and 40% black. The contrast is minimized in most areas, making the solid black of the "Pritchard" sign stand out. In the last example, the base plate is reversed so that the white areas on page 62 print black and vice versa, giving a bright, upbeat feeling to the whole.

For all these examples, the base mechanical consisted of the 100% black areas in the design reproduced on this page. One Rubylith was cut for the dark gray and another for the light gray areas. Finally, there was a separate overlay for some of the type names. A photocopy of the base mechanical was made and color-keyed for the separator.

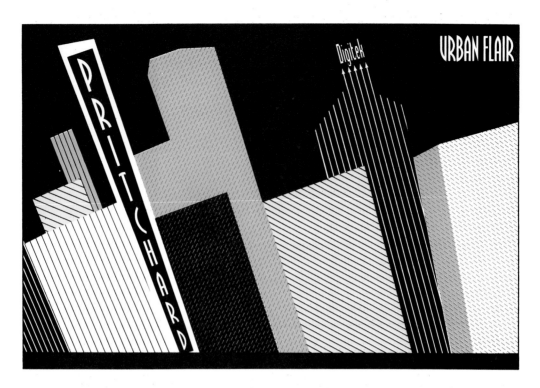

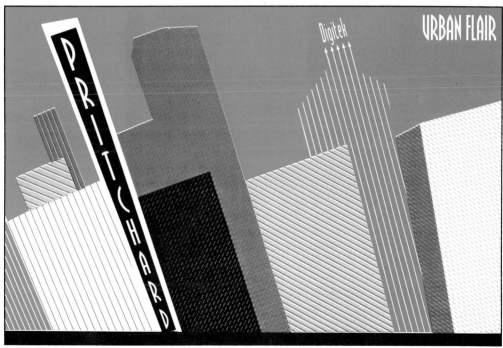

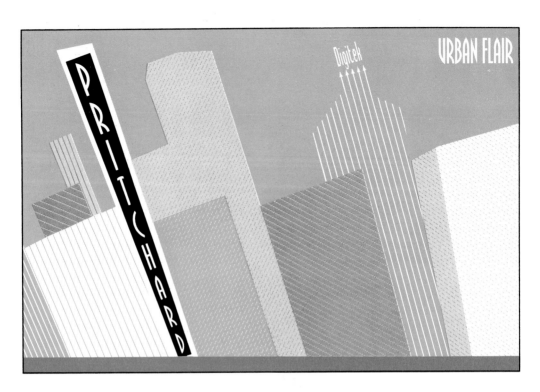

5

USING COOL DIRTY
COLORS

Blue is a very popular choice for a second color. Handled with care, a dirty blue can work just as well as a dirty warm color. But care is needed. People, certain animals such as dogs or cows, and some realistic objects such as food present problems when printed in blue because the color runs strongly counter to our expectations. There are, however, ways of controlling the blue so that it gives the added dimension of a second color without being disconcerting. Still, if a piece consists primarily of head shots or food, a dirty warm color offers greater flexibility.

The dirty blue used in this section is made up of 11 parts process blue, 5 parts green, and 1/2 part black. The amount of black is just enough to allow both the full-strength color and its tints to hold the page, without seeming to jump off or float away. At the same time the black is not enough to really dull the blue. Used full strength, this blue is bright and colorful, with a lot of visual punch.

There is actually more black in this blue than in the dirty orange used in the last chapter. Yet the blue seems brighter than the orange. The difference is that process blue, its primary component, is a much stronger color than the yellow that is the main component of the dirty orange.

PAGE DESIGNS 1

When you compare these layouts with the ones on page 34, you'll find a difference in the overall feel of each spread. Both the dirty warm and the dirty cool work well in fulfilling the second color's main task here—adding visual appeal to the page. In choosing between the two, you need to decide on the emotional tone you want. If, for example, the text concerns home care for the elderly or stresses the importance of intimacy in close relationships, you might prefer a warm color. But, if the text focuses on technological advances in the steel industry or describes a cold, wintry setting, you might opt for a cool color. These choices, though, are subjective—there are no set rules. Also, you must consider how well the color will work for other elements on other pages.

They were sailors and shopkeepers, clerks and soldiers, dreamers from every walk of life, who dropped what they were doing with the news of a strike to pursue their luck in the gold- and silverfields of the West. They came in droves. Indeed, it is estimated that 80,000 fortune-seekers made the journey to California in 1849 alone. Most of them could barely afford a pick, a pan, a mule, and some food. Consequently, the methods that they used for finding gold were rather unsophisticated.

The most popular approach called for the use of a pan with a pourous bottom - or a rocker or cradle - with which a prospector could sift a streambed, washing away the sediment with water while the heavier ore remained behind. Most worked long and hard in this fashion with little to show for their effort; they would have earned more per hour had they stuck with their old jobs. Some drifted from strike to strike for years in search of the Mother Lode. Others gave up and returned home or forged new lives in the West. There were also those who came to the goldfields and built fortunes by supplying the prospectors with badly needed goods and services. Among them was a German immigrant who came to San Francisco with a large supply of canvas which he planned to sell to the miners for tents. When he arrived in the goldfields, however, he found that they needed pants more than shelter, because panning for gold in the rugged terrain had worn out their trousers at the knees. So he used his canvas to make pants, switching to denim when his material ran out. His name was Levi Strauss. And the pants he developed? They became a worldwide phenomenon called blue jeans.

They were sailors and shopkeepers, clerks and soldiers, dreamers from every walk of life, who dropped what they were doing with the news of a strike to pursue their luck in the gold- and silverfields of the West. They came in droves. Indeed, it is estimated that 80,000 fortune-seekers made the journey to California in 1849 alone. Most of them could barely afford a pick, a pan, a mule, and some food. Consequently, the methods that they used for finding gold were rather unsophisticated. The most popular approach called for the use of a pan with a pourous bottom - or a rocker or cradle - with which a prospector could sift a streambed, washing away the sediment with water while the heavier ore remained behind. Most worked long and hard in the rugged terrain had worn out their trousers at the knees. So he used his canvas to make pants, switching to denim when his material ran out. His name was Levi Strauss. And the pants he developed? They became a worldwide phenomenon called blue jeans. They were sailors and shopkeepers, clerks and soldiers, dreamers from every walk of life, who dropped what they were doing with the news of a strike to pursue their luck in the gold- and silverfields of the West. They came in droves. Indeed, it is estimated that 80,000 fortune-seekers made the journey to California in 1849 alone. Most of them could barely afford a pick, a pan, a mule, and some food. Consequently, the methods that they used for find-

ing gold were rather unsophisticated. The most popular approach called for the use of a pan with a pourous bottom - or a rocker or cradle - with which a prospector could sift a streambed, washing away the sediment with water while the heavier ore remained behind. Most worked long and hard in this fashion with little to show for their effort; they would have earned more per hour had they stuck with their old jobs. Some drifted from strike to strike for years in search of the Mother Lode.

Others gave up and returned home or forged new lives in the West. There were also those who came to the goldfields and built fortunes by supplying the prospectors with badly needed goods and services. Among them was a German immigrant who came to San Francisco with a large supply of canvas which he planned to sell to the miners for tents. When he arrived in the goldfields, however, he found that they needed pants more than shelter, because panning for gold in the rugged terrain had worn out their trousers at the knees. So he used his canvas to make pants, switching to denim when his material ran out. His name was Levi Strauss. The pants he developed? They became a worldwide phenomenon called blue jeans They were sailors and shopkeepers, clerks and soldiers, dreamers from every walk of life, who dropped what they were doing with the news of a strike to pursue their luck in the gold- and silverfields of the West. They came in droves. Indeed, it is estimated that 80,000 fortune-seekers made the journey to California in 1849 alone. Most of them could barely afford a pick, a pan, a mule, and some food. Consequently, the methods that they used for finding gold were rather unsophisticated. The most popular approach called for the use of a pan with a pourous bottom - or a rocker or cradle - with which a prospector could sift a streambed, washing away the sediment with water while the heavier ore remained behind. Some drifted from strike to

USING COLOR

At the outset of the 19th century, the nation's leaders expected that it would take 500 years to settle the West. Instead, the 1890 census declared the frontier closed. What made the difference, more than any other single factor, was the railroad.

Spurred on by Congress and the state legislatures - which provided more than $64 million in bonds and 116 million acres in land grants - the railroad companies went from 3,200 miles of short-line track west of the Mississippi in 1865 to 72,000 miles by 1890. When the Railroad Act of 1862 called for the creation of a transcontinental railroad, the Union Pacific started west from Omaha, Nebraska, while the Central Pacific started east from Sacramento, California. Crossing two mountain chains - the Rockies and the Sierra Nevadas - and the Great Basin, with its inadequate supplies.

USING COLOR

Wood and water, they laid an average of two to five miles of track per day. On May 10, 1869, they met at Promontory Summit, Utah and the nation was linked by rail. During the ensuing year, 150,000 passengers made the journey between Omaha and Sacramento. A decade later, the figure approached 1 million. "A journey over the plains was a formidable undertaking, requiring great patience and endurance" reported Frank Leslie's Illustrated Newspaper. "Now all that has changed. . . the six months' journey is reduced to less than a week." And thus the way for people to come West had been eased, and the heavy flow of goods between the frontier and the rest of the nation had begun.

At the outset of the 19th century, the nation's leaders expected that it would take 500 years to settle the West. Instead, the 1890 census declared the frontier closed. What made the dif-

Hollywood liked to portray them as stalwart champions of justice. Bat Masterson called them ordinary men "who could shoot straight and had the most utter courage and perfect nerve - and, for the most part, a keen sense of right and wrong." But neither Hollywood nor Masterson caught the true measure of the law enforcement officer, for more often than not he was a shady character, one who was closer in spirit to the outlaws he was sworn to apprehend than he was to the citizenry in his care. The townfolk didn't really mind if he had been an outlaw before he became a marshal, or if he invested in saloons or brothels as a side-

line as long as he could keep the peace. In areas rife with troublemakers - notably the cowtowns and mining towns - such a pragmatic attitude was perhaps understandable. But, even in the most raucous of communities, gun battles and fistfights were not what occupied the major part of a marshall's time. He spent a good portion of each day doing paperwork. He issued licenses to brothels and saloons, served as the sanitation inspector, and collected taxes (taking a share of the proceeds for himself). Even Wild Bill Hickock, the marshall of Abeline, Kansas, had to keep the streets litter free and patrol for unlicensed dogs. But the local marshall wasn't alone; he was part of a network of frontier law enforcement officers that also

included county sheriffs and, in a few states, quasi-military outfits, like the Texas Rangers. At the pinnacle of this network was the U.S. marshall, appointed by the president to oversee a state or territory. These were political figures. In Colorado, for example, a wholesale liquor dealer was a federal marshall, as was a bank appraiser. Fellows like these usually left the earthier aspects of the job to their deputies.

Hollywood liked to portray them as stalwart champions of justice. Bat Masterson called them ordinary men "who could shoot straight and had the most utter courage

and perfect nerve - and, for the most part, a keen sense of right and wrong." But neither Hollywood nor Masterson caught the true measure of the law enforcement officer, for more often than not he was a shady character, one who was closer in spirit to the outlaws he was sworn to apprehend than he was to the citizenry in his care. The townfolk didn't really mind if he had been an outlaw before he became a marshall, or if he invested in saloons or brothels as a sideline as long as he could keep the peace. In areas rife with troublemakers - notably the cowtowns and mining towns - such a pragmatic attitude was perhaps understandable. But, even in the most raucous of communities, gun battles and

172

173

PAGE DESIGNS 2

These layouts use essentially the same mechanicals as those on page 35, with different instructions for color breaks. They begin to suggest the many alternatives for using color with even a relatively simple page design.

In the first example, the tint panels on page 35 have been changed to 100% color, while the full-color areas are now 50% color. Because of the greater contrast with the white page, the full-color panels seem more separated from the text, serving almost as a countervoice. For the tints, it was necessary to choose a darker tint of color than on page 35 so that there would be enough dots within the small areas for them to read as color. (A 30% tint would not be distinct enough from white.) It was also desirable to drop out the type on the panels to white; surprinting black would not have provided enough contrast for good legibility.

In the second layout, the color and black areas are reversed for a different effect from page 35. The instructions on the mechanical are slightly different, calling for the doodle to be knocked out and then printed over the oval. If it were simply surprinted, the color of the doodle line would darken in the oval area.

The final layout is also an inversion, with the color areas on page 35 printing black and vice versa. The one difference is that the oval here is knocked out of the background and then printed in 40% color, providing a stronger contrast with the background and making the oval more of a focal point. Notice also that the color type on the facing page is quite readable.

The picture above is framed in color and printed in black but dropped out of the background tint.

As people began to populate the West, they hungered for news of home. Just as importantly, events were taking place on the frontier - such as the discovery of gold in California - that were of interest to the people back East. To facilitate communication between the coasts, Congress created an overland mail service in 1857, reducing by more than 50 percent the time that it took to carry a letter from St. Louis to San Francisco (from about two months to about three weeks). Then came the celebrated Pony Express, which offered ten-day service from St. Joseph, Missouri, to San Francisco.

Wiry lads of 18 years or younger galloped all the way, changing mounts every 12 to 15 miles (it took 75 horses for the entire journey). It was difficult and dangerous work, but the Pony Express riders were among the West's most celebrated heroes. Then, in October 1861, the service became obsolete - the transcontinental telegraph had been completed. Still, it took years for telegraph wires to cover the vast expanse of miles of line in the entire nation; by 1900 there were 1.4 million. Businessmen used the new technology to a greater degree than

the average citizen - the wealthiest even maintained ticker tapes in their offices so they could follow fluctuations in the stock market - but the average person could - and did - send telegrams as the occasion warranted.

A more personal form of communication arrived with the advent of the telephone. As with the telegraph, it took time for the new technology to make a difference in the lives of the average Westerner, but, by as early as the mid-1880s, switchboards were cropping up here and there. The terrible isolation borne by so many frontier families had come to an end. As people began to populate the West, they hungered for news of home.

Just as importantly, events were taking place on the frontier - such as the discovery of gold in California - that were of interest to the people back East. To facilitate communication between the coasts, Congress created an overland mail service in 1857, reducing by more than 50 percent the time that it took to carry a letter from St. Louis to San Francisco (from about two months to about three weeks). Then came the celebrated Pony Express, which offered ten-day

This text is dropped out white but the initial is a tint of color.

The son of a Pennsylvania farmer, William Andrews Clark (1839-1925) went West, like so many others, to seek his fortune, but, unlike most, he found it. Starting as a peddler in the goldfields of Colorado, he entered the wholesale business, then went into banking and mining. He also acquired control of several newspapers in Montana and Utah, giant sugar plantations and rich oil-bearing land in California, and extensive real-estate holdings. He created the first water company in Butte, Montana, the first electric light company, and one of the first trolley car companies. In 1884, he decided to create a mansion befitting his station as one of the nation's wealthiest men. Three years later, the three-story, 30-room home designed in the Renaissance revival style by Los Angeles architect C. H. Brown was completed. It cost approximately $280,000 at a time when Clark's estimated earnings came to $17 million a month!

European craftsmen handcarved woodwork throughout the house and frescoed the ceiling of every room of the first two floors. The mansion boasted a 62-foot- long ballroom, stained glass windows by Louis Comfort Tiffany, fixtures fitted for incandescent lighting as well as gas, and an impressive main staircase with intricately carved panels of birds and flowers from various countries of the world. The latter, called "The Staircase of Nations," was removed from the house in 1903 and exhibited at the St. Louis World's Fair. Eventually, when Clark became a U.S. Senator, he erected a 121-room mansion in New York City. That structure was torn down, at his request, upon his death, but his home in Butte survived. The oldest mansion in Montana, it is privately owned by Mrs. Ann Cote Smith, who lovingly restored the home with

W ilson liked to portray them as stalwart champions of justice. Bat Masterson called them ordinary men "who could shoot straight and had the most utter courage and perfect nerve - and, for the most part, a keen sense of right and wrong." But neither Hollywood nor Masterson caught the true measure of the law enforcement officer, for more often than not he was a shady character, one who

PAGE DESIGNS 3

These layouts should be compared with those on page 36. Again, pay attention to the different feeling of the cool and the warm color.

In the top example, the mechanical is the same, but the instructions are slightly different. On the left side, the type is reversed, dropping out white on a black background. This reversal has a strong impact on our spatial reading of the page. The black panel pushes forward, as if it were pasted on top of the color page, while the white panel on page 36 looks more like a window cut into a frame of color.

The next layout inverts the tint and full-color areas on page 36. The result simply doesn't work, as the 30% tint of color is not strong enough to carry the fine lines in the design on the left or to be readable as color in the letters on the right. Either a darker tint is needed or the tint area must be larger. Compare the effectiveness of the 30% color in the background of the middle left bar graph on page 72, where the color area is much larger and the white lines are thicker. It's hard to believe that it's the same tint.

The third layout is the same as the one on page 36. Here, however, there is less visual contrast between the black panel and the full-color "S," which decreases its legibility.

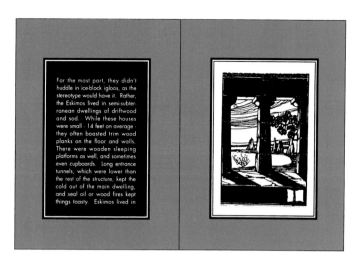

PAGE DESIGNS 4

These layouts are variations of those on page 37. The mechanicals are the same; only the instructions differ.

In the first design, everything is the same as page 37, except the left panel and the art within it are 100% color and the frame is 100% black. The effect is softer, as the blue panel merges with the light (20%) blue background. It is also visually linked to the color initial and ampersand on the right. Note that the art merges into the color background. Another variation would be to print both the art and the rules in solid black.

The middle design is a partial reversal of the one on page 37. Although the left side is the same, the right side uses 100% color type on a 30% color background. Putting the type in the darker color is certainly more readable; it is also more conventional.

The last layout is quite different in effect from the one on page 37. Part of the difference comes from the change of color, but part is also due to the variation in color contrast. The white outline letters on the right are more legible on the black, where there is greater value contrast. Along the same lines, on the left the black quotation marks seem to jump out of the 60% blue background. There would be less of a contrast if these were 60% black, the color of the background on page 37.

BAR GRAPHS 1

Both the mechanicals and color breaks here are the same as those on page 38; only the color is different. Which color works better is purely a matter of taste. The blue admittedly is a stronger, more "colorful" color than the orange (as discussed on page 65). But the orange is equally legible, which is what's important here.

To get a better idea of the visual effectiveness of an individual graph, mask out the other graphs with a piece of paper. Even though the graphs themselves are discrete, the neighboring graph is always in the corner of your eye, influencing what you see.

BAR GRAPHS 2

All but two of these graphs have the same color breaks as the graphs on page 39. The middle right graph has bars of 40% rather than 60% black, which makes the bars read further forward. The bottom left graph has rules of 60% instead of 100% black, so there is no distracting value difference. Also, in the latter graph the bars knock out the rules, so the bars seem more substantial. These changes indicate just a few of the subtle shifts in tints available to you.

In general, both the dirty warm and the dirty cool color work equally effectively here. The improvement in the bottom left graph is due more to the fact that the bars knock out the rules than to any inherent color differences.

Also compare this page to the preceding one. Notice how the color and the impact of the blue change depending on its proportion to the colors surrounding it. For example, the blue looks duller when it covers the background in the top right and middle left graphs on this page than it does when it colors the bars against a field of black or white in the bottom four graphs on page 70.

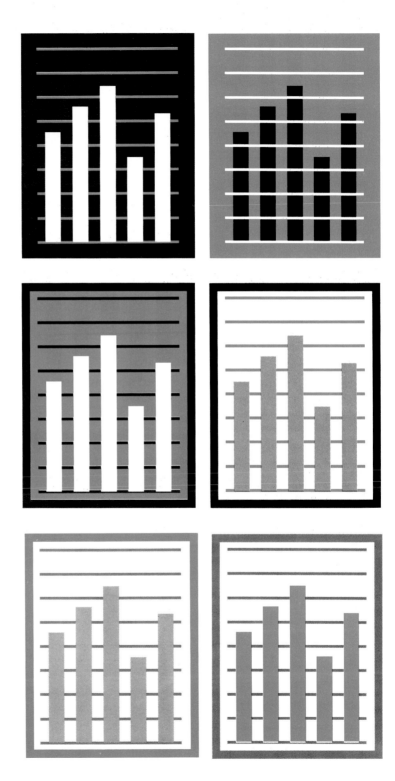

BAR GRAPHS 3

These graphs repeat the ones on page 40; the difference is that here tints of 30% color or 30% black are used instead of 60%. Notice how much variation there is in the perceived color of the same tint. Certainly it is hard to believe that the 30% blue in the middle right is the same as the 30% blue in either the graph next to it or above. But if you look through a loupe, you'll see that the dot pattern is the same. Also compare the gray background on the top left with the gray bars on the bottom left—both 30% black.

In a few of these graphs, the 30% blue may seem too close to baby blue for some tastes. To modify this tint you could add a 10% screen of black or you could change it to a stronger tint.

The middle right graph presents another problem. A disturbing optical effect occurs where the blue bars and white rules intersect. You see a flicker of a very light black rule continuing through the blue, which makes it hard to look at the color bars as a whole. (The same effect can be seen in the corresponding graph on page 40.) The element to change is the black background, not the rules or bars.

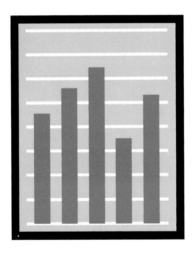
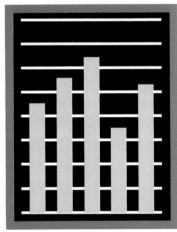
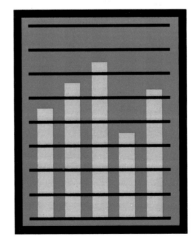
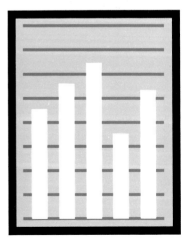

BAR GRAPHS 4

These graphs introduce several new possibilities for combining two tints with solids, beyond those shown on page 41. On the top left the background is 40% color and the bars are 60% black, so there is less contrast between the bars and the background than on page 41. The next graph, to the right, has 20% black in the background, like the one on page 41, but note the difference in the color of the grays. Another difference is that here the rules are 60% color and the bars are 100% color, making the bars seem more substantial. Yet note the distracting optical effect when the lighter-value rules cross the darker-value bars. This effect is not present on page 41, where the rules are darker.

The middle left graph has the same color breaks as the one on page 41, but here the bars knock out the rules, so the whole is more readable. The next graph—with the transparent bars—is also the same as the corresponding graph on page 41. Compare this with the top left graph, where the gray bars also surprint. In the top, however, the bars are 60% black—versus 40% here—and they surprint a much lighter background, making them read as solids.

The bottom left graph has 40% black bars like the preceding graph, but here they are knocked out of the background. The difference is remarkable. The last graph differs from page 41 in its darker (60% color) rules and lighter (30% black) frame. Notice how the shift in value shifts the emphasis in the graph.

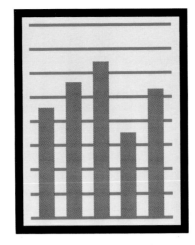
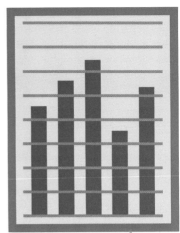
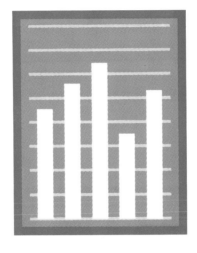
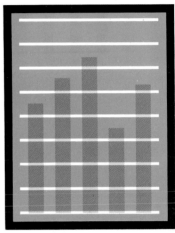

MAPS

The three maps on this page are directly comparable to the maps on page 42. Here, however, the top map is harder to read as there is less contrast between the blue and the black. Also note that in the bottom map on both pages, a slightly heavier line weight is used where the outlines are dropped out.

The top map on page 75 inverts the color breaks on page 43. Again, it is not easy to distinguish the black lines from the blue. There is also a strong visual contrast between the light (30%) blue and the solid color, making the emphasized area pop out. You may want maximum contrast, but less contrast would function as well and be more pleasing visually. In the bottom map, the black of page 43 has been toned down to 60% black. There is still a lot of contrast, which is accentuated by the white outlines.

On the next page the two maps follow the same color breaks as those on page 44. Most striking is the different overall feeling of the cool and warm versions. Also, compare the difference in the background gray color in the bottom map. Gray—a "neutral" color—is strongly affected by the color around it. Notice in the top map that there is slightly less distinction between the color of the northeastern and western states in the blue version than in the orange.

On page 77 the color breaks are the same as those on page 45. In the top map the grays don't blend as well in the blue version; specifically, the light and dark grays stand out more. In the bottom map, however, the blue version offers more contrast than the orange, making it more effective.

Gasket

Retainer strips

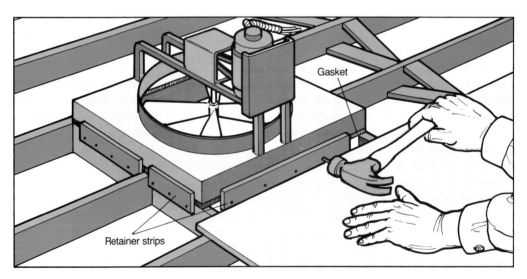

Gasket

Retainer strips

DIAGRAMMATIC ART 1

These diagrammatic drawings illustrate what happens when a color runs counter to our expectations. Both examples on this page use the same color breaks as the ones on page 46. In the first drawing, the blue color does not present any problems, in part because it is used for machinery (which might be a steel blue) and in part because the use of color in general is more abstract. The second illustration, however, is disconcerting. While the dirty orange version is plausible in realistic terms, the blue hands can only be seen as a mistake.

There is, incidentally, one small difference in the coloring of the second blue and orange examples. In the blue version the top of the support near the retainer strips is 60% color; in the orange version it is 40% black. Color-keying an illustration like this—with six distinct color areas (not counting the black outlines or white paper)—is a complicated job, requiring careful attention to detail.

DIAGRAMMATIC ART 2

These illustrations parallel those on page 47. The top example again presents the problem of blue hands. Because the illustration as a whole is more abstract, the effect is slightly less disturbing than on page 78, but only slightly less. In the bottom illustration the hands are a light gray—a much more believable choice. Also, the black outline around the hands is less disconcerting than the orange outline on page 47.

Notice in the diagrams here and on page 47 that in reversing the color and black plates a portion of the leader lines for "Retainer strips" has been lost. It would have been better to reposition the label on the mechanical, bringing it closer to the leader lines.

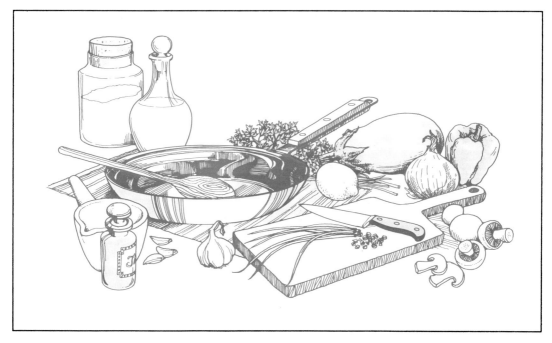

ART WITH LINE AND TONE 1

Except for color, these illustrations are the same as those on page 48.
But color makes a difference. Some people may dislike the blue food
in the top example. The second illustration is more acceptable, as it is
more abstract. You may even prefer the blue version, with its greater
contrast, to the orange.

ART WITH LINE AND TONE 2

Although the top illustration here is more abstract than the art on top of page 80, the blue food is still unappetizing. The bottom illustration is more acceptable; it also offers greater contrast than its counterpart on page 49.

PHOTOGRAPHS OF PEOPLE 1

Using blue or another cool color with people requires special care because our expectations of a warm skin coloring are so strong. In these head shots, which repeat those on page 50, the blue is particularly problematic in the top pair.

The 30% blue in the middle is a bit more acceptable—but only a bit. It still looks unnatural. If you want a flat tint in a situation like this, it is better to specify a very light blue (about 10%).

The bottom pair is undoubtedly the best use of the second color on this page. By limiting the color to the background and silhouetting the heads, you avoid the suggestion of blue skin. The strong contrast between the full-strength color and the halftone, however, does create a cutout effect. To reduce this effect, you might prefer a tint of blue in the background.

PHOTOGRAPHS OF PEOPLE 2

These duotones reverse the black and the color film used on page 51. In the top pair, both the black and the color plates are normal halftones, so the result is the same as on page 51, except that the blue offers more contrast than the orange (which is a lighter color). The middle shots contain a normal halftone in color and a flat halftone in black, while the bottom pair consists of a normal halftone in color and a dropout halftone in black. (This is the reverse of page 51, where black was used for the normal halftone in all three pairs.) Because black is the stronger color, making the plate printed in black dominate, the differences between the images are somewhat clearer than they were on page 51. The middle images are the flattest and the bottom the most contrasty.

Overall, the dirty orange duotones are softer, but more natural-looking, than the dirty blue ones. One reason is that the blue is darker than the orange and thus provides greater contrast with the highlights. Another reason, of course, is the steely coolness of the dirty blue compared with the warm sepia tones derived from the dirty orange.

PHOTOGRAPHS OF PEOPLE 3

All these examples make use of special effects. Since the images are more abstract, an "unnatural" color like blue seems less problematic than it would in a realistic depiction.

In the top shots, the plates used on page 52 are reversed: the posterization prints in black here and the halftone in color. The result is strikingly different because the black posterization now dominates. The one place the blue stands out is in the highlight areas (which are white in the posterization).

The middle image shows a needle-point-like screen in black printed over 30% blue. Here you can see more clearly the design of the screen printed in color on page 52.

The final pair shows a black solarization printed over 100% color. Compare this with the halftone printed over color on the top of page 82. Although the special-effect image is bizarre, it might look just right on a record cover album or a rock poster. The normal halftone printed on blue would not.

PHOTOGRAPHS OF OBJECTS 1

These images were created in the same way as those on page 53: on the left a black halftone surprints 100% color and on the right a color halftone surprints 30% black. Because the original photograph is relatively abstract, it works well with either the blue or the orange. The choice is primarily a matter of personal taste, as well as the mood you want to create.

On the left the strength of the blue as a color gives the whole a strong impact as a design element. On the right, note how the color of the blue affects the gray, giving it a warmer tone than the gray on page 53.

PHOTOGRAPHS OF OBJECTS 2

The left duotone, like the one on page 54, consists of a normal black and a normal blue halftone. Compare this to the black-and-white halftone on the preceding page to see what the dimension of color adds.

The right duotone reverses the plates of its counterpart on page 54, so the normal halftone prints in black and the contrasty halftone prints in color. As a result, there is slightly less overall contrast than on page 54. The black from the mid-range halftone grays the highlights. Still, there is significantly more contrast than in the normal duotone.

PHOTOGRAPHS OF OBJECTS 3

This duotone uses the same combination as the one on page 55: here
the dropout halftone prints in black and the contrasty halftone in color.
Most striking is the difference in color between the two images—one
icy cold, the other glowingly warm. Also notice that with the blue, the
darker color, there is even more loss of detail in the shadow areas.
Compare, for example, the bottom ends of the tube that opens out to
the top right. Also compare the middle foreground areas.

PHOTOGRAPHS OF OBJECTS 4

Like the duotone on page 56, this image consists of a flat halftone
printed in color and a dropout halftone printed in black. The effect,
however, is quite different, due in large part to the different feeling of
warm and cool tones. Another factor is the value difference between
the blue and the orange. Because blue is the darker color, the shadow
area is darker. At the same time the highlights are not as bright, as the
blue from the flat halftone fills them.

PHOTOGRAPHS OF OBJECTS 5

These images, like those on page 57, use a contrasty line conversion
in black on the left and in color on the right. The other plate is a flat
halftone. The main difference is in the feeling created by the blue or
orange color. This difference is more obvious on the left. On the right,
the blue image seems almost colorless, as the blue merges with the
black. (Check this by looking through a loupe.) At the same time this
blue image shows slightly more contrast than the orange one because
the blue is a darker color.

PHOTOGRAPHS OF OBJECTS 6

These images use the same mezzotint-like screen as those on page 58. On the left the screen is printed in color over 40% black, and on the right it is printed in black over 100% color. In addition, to the warm/cool difference, note the difference in the grays on the left. As explained earlier, gray often moves toward the complement of the dominant color, so it seems warmer with the blue and cooler with the orange.

Also compare the right image with the top left image on page 85. Because the granular screen adds to the abstractness of the image, diminishing our expectations of realistic coloring, the strong blue here may seem more fitting than the blue on page 85.

PHOTOGRAPHS OF OBJECTS 7

The difference between these images and those on page 59 is that the plates are reversed. In the left image here, the posterized line screen is in black and the conventional line screen in color. If you look closely, you can see a slight variation in texture between the two. More significantly, the posterized black dominates the blue image, much as it did on top of page 84, so the blue version seems less colorful than the orange.

In the right image, the solarization is in color and the line conversion in black. Because this photograph's many dark areas are reversed in the solarized image, the black from the line conversion (where the shadows are not reversed) tends to fill the dark areas. In other words, the impact of the solarization here is nowhere near as great as on page 59, so the blue version seems much less abstract than the orange.

PHOTOGRAPHS OF OBJECTS 8

These 40% ghosted halftones, printed over 10% black on the left and 30% color on the right, parallel those on page 60. The primary consideration in selecting one or the other is the mood you wish to establish. To get a better idea of the effect of each, isolate it with a piece of white paper.

PHOTOGRAPHS OF OBJECTS 9

The final special effect uses a line conversion printed over 30% black, as on page 61. Notice, once again, the difference in the grays. Compared to blue, the gray areas look warm; compared to orange, they look cool.

PURE GRAPHIC IMAGES 1

The same color breaks are used here as on page 63. The blue may
seem more appropriate than the orange, given the cityscape refer-
ence in the design. In the bottom example, the blue suggests the sky.

PURE GRAPHIC IMAGES 2

It may be hard to believe that only two colors were used for here. The words at the top have a silvery feel, but if you check through a loupe you will discover only blue and black dots in different proportions. The grainy black areas around the fighters' outfits (which are 40% color) give the figures dimensionality and separate them sharply from the solid blue background.

PURE GRAPHIC IMAGES 3

This image is flatter and somewhat more abstract than the version
on the preceding page; it is also more obviously done in two colors.
Yet, with the solid black background and the white outline around the
figures, it is quite dramatic. Notice how the change in the light/dark
progression of the word "Rapier" moves the eye into the sword here
and up and out on the preceding page.

6

USING COOL CLEAN
COLORS

C lean colors—colors without any black or white—are the brightest colors available. This brightness can be an asset, but it can also be a liability. A pure hue on a bright white paper immediately catches the eye. It is dazzling. But this very quality can interfere with readability. A design can be too bright to look at for more than a moment.

The color and the finish of the paper you use become important considerations. A slightly off-white uncoated paper will lessen the intensity of an overly bright color. With a coated stock, a matte or dull finish will tend to mute the color. Clean colors are shiniest on a glossy coated stock.

With clean colors, tints also present problems, frequently becoming weak pastels. Although you can add black to give the color more visual weight, the overall range of tints you can work with is limited.

The cool clean color in this section is process blue, a slightly greenish blue and the main component of the dirty blue used in Chapter 5. Process blue (cyan) is a clean color you may find yourself using on a four-color-process job. It is more workable than process yellow or magenta, although —as you will see—it must be handled with care.

PAGE DESIGNS 1

When you compare these layouts with the similar versions in dirty blue (pages 66–67), the distraction of the bright color is readily apparent. Although the process blue certainly catches your eye in the first two examples, it is hard to get past this color. Isolate one of these layouts (masking out the others) and try reading the text. Doesn't your eye keep shifting back to the bright blue at the periphery of your vision? Also try staring at the page as a whole for a while. Again, it's hard to keep a steady focus.

In the third spread, notice the shimmer of the blue type. The blue color may look lively and attractive from a distance, but it doesn't invite you to read the text. The dirty blue type on the bottom of page 67 is much quieter, with less noise to distract you from reading.

The blue tint in the oval of this design may also be problematic. The color is a "baby blue," and that may carry associations or a sense of prettiness that you don't want.

USING COLOR

At the outset of the 19th century, the nation's leaders expected that it would take 500 years to settle the West. Instead, the 1890 census declared the frontier closed. What made the difference, more than any other single factor, was the railroad.

Spurred on by Congress and the state legislatures - which provided more than $64 million in bonds and 116 million acres in land grants - the railroad companies went from 3,200 miles of short-line track west of the Mississippi in 1865 to 72,000 miles by 1890. When the Railroad Act of 1862 called for the creation of a transcontinental railroad, the Union Pacific started west from Omaha, Nebraska, while the Central Pacific started east from Sacramento, California. Crossing two mountain chains - the Rockies and the Sierra Nevadas - and the Great Basin, with its inadequate supplies.

USING COLOR

Wood and water, they laid an average of two to five miles of track per day. On May 10, 1869, they met at Promontory Summit, Utah and the nation was linked by rail. During the ensuing year, 150,000 passengers made the journey between Omaha and Sacramento. A decade later, the figure approached 1 million. "A journey over the plains was a formidable undertaking, requiring great patience and endurance" reported Frank Leslie's Illustrated Newspaper. "Now all that has changed. . . the six months' journey is reduced to less than a week." And thus the way for people to come West had been eased, and the heavy flow of goods between the frontier and the rest of the nation had begun.

At the outset of the 19th century, the nation's leaders expected that it would take 500 years to settle the West. Instead, the 1890 census declared the frontier closed. What made the dif-

Hollywood liked to portray them as stalwart champions of justice. Bat Masterson called them ordinary men "who could shoot straight and had the most utter courage and perfect nerve - and, for the most part, a keen sense of right and wrong." But neither Hollywood nor Masterson caught the true measure of the law enforcement officer, for more often than not he was a shady character, one who was closer in spirit to the outlaws he was sworn to apprehend than he was to the citizenry in his care. The townfolk didn't really mind if he had been an outlaw before he became a marshall, or if he invested in saloons or brothels as a side-

line as long as he could keep the peace. In areas rife with troublemakers - notably the cowtowns and mining towns - such a pragmatic attitude was perhaps understandable. But, even in the most raucous of communities, gun battles and fistfights were not what occupied the major part of a marshall's time. He spent a good portion of each day doing paperwork. He issued licenses to brothels and saloons, served as the sanitation inspector, and collected taxes (taking a share of the proceeds for himself). Even Wild Bill Hickock, the marshall of Abeline, Kansas, had to keep the streets litter free and patrol for unlicensed dogs. But the local marshall wasn't alone; he was part of a network of frontier law enforcement officers that also

included county sheriffs and, in a few states, quasi-military outfits, like the Texas Rangers. At the pinnacle of this network was the U.S. marshall, appointed by the president to oversee a state or territory. These were political figures. In Colorado, for example, a wholesale liquor dealer was a federal marshall, as was a bank appraiser. Fellows like these usually left the earthier aspects of the job to their deputies.

H ollywood liked to portray them as stalwart champions of justice. But Masterson called them ordinary men "who could shoot straight and had the most utter courage

and perfect nerve - and, for the most part, a keen sense of right and wrong." But neither Hollywood nor Masterson caught the true measure of the law enforcement officer, for more often than not he was a shady character, one who was closer in spirit to the outlaws he was sworn to apprehend than he was to the citizenry in his care. The townfolk didn't really mind if he had been an outlaw before he became a marshall, or if he invested in saloons or brothels as a sideline as long as he could keep the peace. In areas rife with troublemakers - notably the cowtowns and mining towns - such a pragmatic attitude was perhaps understandable. But, even in the most raucous of communities, gun battles and

172

173

The son of a Pennsylvania farmer, William Andrews Clark (1839-1925) went West, like so many others, to seek his fortune, but, unlike most, he found it. Starting as a peddler in the goldfields of Colorado, he entered the wholesale business, then went into banking and mining. He also acquired control of several newspapers in Montana and Utah, giant sugar plantations and rich oil-bearing land in California, and extensive real-estate holdings. He created the first water company in Butte, Montana, the first electric light company, and one of the first trolley car companies. In 1884, he decided to create a mansion befitting his station as one of the nation's wealthiest men. Three years later, the three-story, 30-room home designed in the Renaissance revival style by Los Angeles architect C. H. Brown was completed. It cost approximately $280,000 at a time when Clark's estimated earnings came to $17 million a month!

European craftsmen handcarved woodwork throughout the house and frescoed the ceiling of every room of the first two floors. The mansion boasted a 62-foot- long ballroom, stained glass windows by Louis Comfort Tiffany, fixtures fitted for incandescent lighting as well as gas, and an impressive main staircase with intricately carved panels of birds and flowers from various countries of the world. The latter, called "The Staircase of Nations," was removed from the house in 1903 and exhibited at the St. Louis World's Fair. Eventually, when Clark became a U.S. Senator, he erected a 121-room mansion in New York City. That structure was torn down, at his request, upon his death, but his home in Butte survived. The oldest mansion in Montana, it is privately owned by Mrs. Ann Cote Smith, who lovingly restored the home with

PAGE DESIGNS 2

If you thought the last page was hard to look at, you will certainly have difficulties with this one. The top example is particularly overwhelming. Although there is a strong impact of color in the comparable dirty blue design on page 68, the color sits back on the page; it does not shout out.

To give the middle example a fair chance, mask out the other two designs on this page. The blue is still potent, but its brightness seems in keeping with the straightforward design, and it is balanced by the strong black rectangle. In fact, the clean blue works better than the dirty blue on page 68. Because process blue does not contain any black, it stands out more from the black rectangle than the dirty blue does.

Now isolate the last example. This layout also shows a possible use of the process blue. Compare it with the corresponding design in the dirty warm color on page 37. You may even prefer the blue to the orange. The large area of gray helps to tone down the blue. Also, because the white is clearly used as a color in its own right here, the blue does not stand out as much. It is the brilliance of the white that first attracts your eye.

For the most part, they didn't huddle in ice-block igloos, as the stereotype would have it. Rather, the Eskimos lived in semi-subterranean dwellings of driftwood and sod. While these houses were small - 14 feet on average - they often boasted trim wood planks on the floor and walls. There were wooden sleeping platforms as well, and sometimes even cupboards. Long entrance tunnels, which were lower than the rest of the structure, kept the cold out of the main dwelling, and seal oil or wood fires kept things toasty. Eskimos lived in

S o they were sailors and shopkeepers, clerks and soldiers, dreamers from every walk of life, who dropped what they were doing with the news of a strike to pursue their luck in the gold- and silverfields of the West. They came in droves. Indeed, it is estimated that 80,000 fortune-seekers made the jour-

ney to California in 1849 alone. Most of them could barely afford a pick, a pan, a mule, and some food. Consequently, the methods that they used for finding gold were rather unsophisticated. The most popular approach called for the use of a pan with a porous bottom - or a rocker or cradle - with which a prospector could sift a streambed, washing away the sediment with water while the heavier ore remained behind. Most worked long and hard in this fashion with little to show for their effort; they would have earned more per

For the most part, they didn't huddle in ice-block igloos, as the stereotype would have it. Rather, the Eskimos lived in semi-subterranean dwellings.

QUOTES

BAR GRAPHS 1

These bar graphs, which use primarily solid colors, should be compared with those on pages 70 and 71. It is surprising how well the process blue does work. The top left and middle right graphs, where the clean blue is limited to the background rules, are easy to read. The bottom right graph, with the bright blue bars, is also quite acceptable and might even help enliven a dry statistical report.

Most problematic is the top right graph, where the interaction between the shimmering blue background and the bright white rules leaps to the foreground. The black bars, which contain the most information, are seen only as an afterthought.

The middle left graph works reasonably well, but the bright blue frame is distracting. If the frame were black or a dark gray, like the 60% black in the bottom right graph, the bars would be the sole center of our attention. A similar point might be made with the graph on the lower left, although here there is also a distracting after-image when you focus on the bars. The same problem occurs with the corresponding graph on page 70 and the middle right graph on page 72. The culprit here is the black background, not the blue.

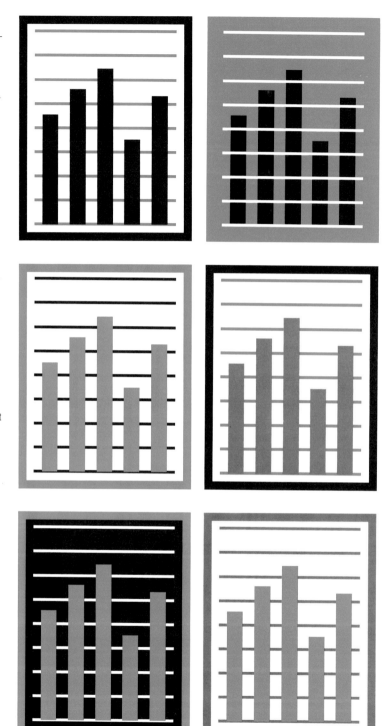

BAR GRAPHS 2

The first two pairs of graphs show the difference between a pure color and the same color with a touch of black. On the top left the background is 30% process blue, while on the top right it is 30% process blue plus 10% black. Even this small amount of black tones down the blue, so it fades more into the background. Changing the background also seems to dull the full-strength process blue in the rules and frame, holding them on the page.

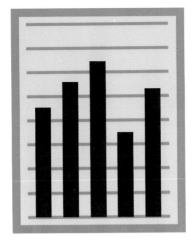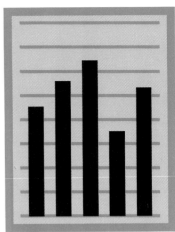

The middle graphs both have 40% black bars, 60% black frames, and 40% process blue rules; the difference is that the left graph has a solid blue background and the right, solid blue plus 10% black. Again, the small amount of black keeps you from focusing on the background; it also changes the apparent color of the light blue rules. If you compare the right graph with the lower left graph in dirty blue on page 73, you may prefer the process blue plus black, as it offers a stronger contrast with the bars. Note the difference in the grays.

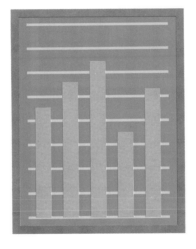

The bottom left example is comparable to the top right graph on page 41. The color rules and bars surprint the 20% black background, so they are toned down. Because the blue is darker than the orange on page 41, the bars look less transparent. The last example has the same color breaks as the middle left graph on page 73. Its background—60% blue plus 20% black—is the same as the bars on the left, but the effect is different. Here it seems almost gray, compared with the brighter blue frame and strong white bars.

MAPS

The first map, colored 60% process blue plus 20% black, clearly shows how adding black lets you use clean color in a large area. Imagine what the map would look like in 100% process blue; you'd have to look away from the glare.

The second example offers a direct comparison with the use of a dirty blue on page 74. The white surrounding the process blue augments the overall shimmer; in contrast, the dirty blue augments the gray, dulling the white to some degree. The clean blue version jumps out from the gray, while the dirty blue map sits back quietly in the gray.

In the bottom example, the light blue background—a baby blue—takes over, drawing almost as much attention as the map. Adding a small amount of black, as with the bar graphs on the preceding page, would make this more readable.

On page 103 the top map repeats the color breaks on pages 44 and 76, except that here the 100% color area at the top right has been toned down with 10% black. Although this 10% mutes the solid blue somewhat, the color would pop out less with a touch more black.

The last map, corresponding to the versions on pages 45 and 77, includes both pure tints of color and grayed areas. Like the dirty blue version, the light/dark contrasts move the eye back and forth, so the map is more difficult to see as a whole. A different optical effect can be seen in the light gray areas, which look orangish, even though there are only dots of black. The shift toward the complement is more pronounced than with the dirty color because this is a bluer blue.

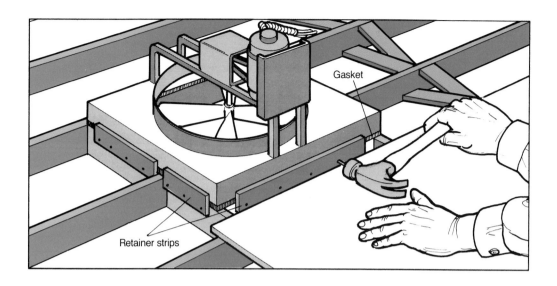

Gasket

Retainer strips

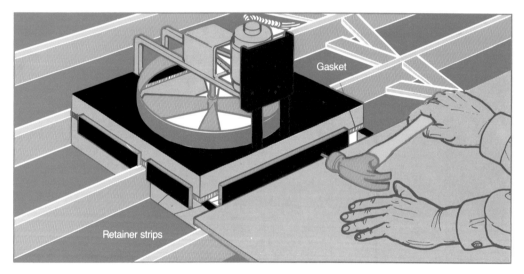

Gasket

Retainer strips

DIAGRAMMATIC ART

If you isolate the top example, the process blue works, even if it is not realistic, because there is enough gray surrounding the blue to tone it down. The very light (10%) blue between the solid blue crossbeams also reduces their impact. Had this area been white, there would be far more dazzle. Also note that, unlike the dirty cool version on page 78, there are no blue hands to jolt the viewer.

The bottom version is just too bright. If you came across this diagram in a home improvement manual, it's doubtful that you'd spend much time studying it. There is, however, one part that works better in this version than in the dirty orange version on page 47. The blue outlining of the hands is less offensive than the orange.

ART WITH LINE AND TONE

The top illustration, like the one on page 80, clashes with our expectations of how food should look. The bottom rendering is much more acceptable, as the whole is more abstract and the blue is read as an outline, not as the color of food. Although grayed by the black tint, the process blue here is more colorful than the dirty blue on page 81.

PHOTOGRAPHS OF PEOPLE

It is hard to dwell on the faces in the first example because the intensity of the process blue is so overwhelming. Compare this with the dirty blue version on page 82, where the black pigment in the blue brings it closer to the halftone, even though there is still a cutout effect.

The middle pair here is also silhouetted against a blue background, but, as it is only 10% blue, the effect is far less jarring. Instead, the hint of color adds interest. This light tint would also be a good choice if you wanted to print the halftone over a tint background, as was done in the middle example on page 82.

The bottom example shows how well a bright color can work with special effects: in this case, a black solarization over a color line conversion, as on page 52. Because with special effects the images are already abstracted, a bright color can work just as well as a dirty color and sometimes even better (when you want to dazzle the viewer, for instance).

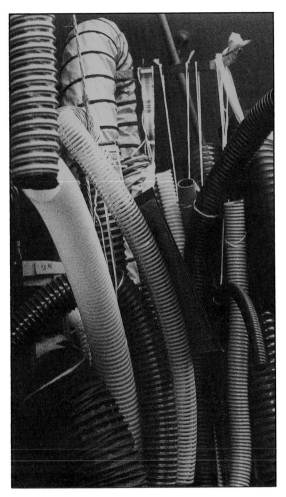

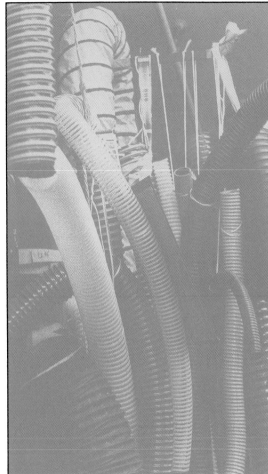

PHOTOGRAPHS OF OBJECTS 1

When you compare this to the dirty blue version on page 85, what stands out is not that one works better than the other but simply that the colors are different. Which you prefer is a matter of taste and of how you intend to use the image.

The abstract nature of the subject is key to the impact of the second color here. With a landscape or a more immediately identifiable industrial scene, you might want to use the second color differently.

PHOTOGRAPHS OF OBJECTS 2

The most effective way to use a clean color with a photograph is to
specify a special-effect screen such as the grainy mezzotint-like
screen used here. These images are just as effective as those on
page 90. Compare the grays in the left versions. Both are warm grays,
but the exact color differs because of the color difference between the
blues. Also compare the right image with the top left image on page
107. The graininess of the line screen here breaks up the blue, mixing
it more with the black, so that the image seems softer.

PHOTOGRAPHS OF OBJECTS 3

The left image repeats the use of posterized and conventional needle-point-like line screens on page 91. At first glance the result is so uncolorful that you may find it hard to believe process blue was used. If, however, you hold the page at an angle, you can see the many bright blue dots. But there are so many black dots surrounding the blue ones that your eye optically combines them, and you see a blue black.

The second image consists of a solarization in black and a line conversion in color, like the right image on page 59. Although the blue is bright, it enlivens the abstracted photograph. The image makes no attempt at realistic depiction, so there are no set expectations for color. Also compare this version with the one on page 91, where the plates are reversed. When the solarization is muted, the result is far more sedate.

PHOTOGRAPHS OF OBJECTS 4

With this line conversion, the process blue works just as well as the dirty blue on page 93. Also compare this image with the dirty orange version on page 61. The difference in the grays in both temperature and value is startling. Against the lighter-value orange the gray appears much darker than against the blue. Because of its greater value contrast, the clean blue version seems more dynamic than the orange.

PURE GRAPHIC IMAGES 1

The intensity of the blue background and the sweetness of the baby
blue may not appeal to everyone, but a lot depends on the context. If
you are designing an outdoor poster, where there is a lot of competi-
tion for attention, you may want the brightest color just because it is
eye-catching.

PURE GRAPHIC IMAGES 2

This version repeats the one on page 96. The strong black back-
ground paired with the bright blue adds excitement, making the eye
move forward and back just like the sword fighters. Because the blue
vies with the black for attention, it doesn't leap off the page as much
as the blue on the preceding page.

7

USING WARM CLEAN
COLORS

I t is tempting to use a bright clean color because it is attractive and cheerful. And at times you may be required to select a pure color for a specific reason, such as matching a corporate logo. Used in small areas, intense color can enliven a page—for example, as slender bars in a routine graph. But there are difficulties in using bright color full strength, where it can be too dazzling, and in tints, where it may not carry enough visual weight (see page 97).

One of the most popular second colors is a clean red. To attract potential buyers' eyes, we chose a bright red for the cover of this book. But this red—made up of equal parts of yellow and rubine red—contains some blue (from the rubine red), so it conveys more depth than some other clean reds. The same red is used in the beginning of this book, where we wanted a bright color for the discussion of color characteristics. You may find some of the tints too pink —although in small quantities they are less offensive than they would be over a full page.

For this chapter, we have chosen a bright orange, made up of 13 parts yellow and 3 parts warm red. This color provides a good contrast with the dirty orange in Chapter 4. Also compare it with the clean cool color in Chapter 6.

PAGE DESIGNS 1

These designs use the same mechanicals as the dirty orange versions on pages 34 and 35 (although the instructions differ on the last example). Without doubt, the color of the first two layouts is more upbeat and sparkling than the dirty orange. The question is: is there too much sparkle? The bright orange is lighter than the cool clean blue on page 98, so there is less value contrast to compete with the white page—especially if you don't use a glossy stock (see the discussion on page 97). But ask yourself how you would feel seeing this orange page after page in a book or long magazine article. In choosing a color you must consider the effect not only on one page, but throughout a publication.

The third example seems to be the most effective use of the bright color here. Restricted to a few thin lines and toned down by the prevailing black of the text, the color is upbeat but not overpowering. You should not, however, use the bright orange for type, as was done with the dirty orange on page 35. The result would be even more dazzling and harder to read than the bright blue on page 98.

At the outset of the 19th century, the nation's leaders expected that it would take 500 years to settle the West. Instead, the 1890 census declared the frontier closed. What made the difference, more than any other single factor, was the railroad.

Spurred on by Congress and the state legislatures - which provided more than $64 million in bonds and 116 million acres in land grants - the railroad companies went from 3,200 miles of short-line track west of the Mississippi in 1865 to 72,000 miles by 1890. When the Railroad Act of 1862 called for the creation of a transcontinental railroad, the Union Pacific started west from Omaha, Nebraska, while the Central Pacific started east from Sacramento, California. Crossing two mountain chains - the Rockies and the Sierra Nevadas - and the Great Basin, with its inadequate supplies.

Wood and water, they laid an average of two to five miles of track per day. On May 10, 1869, they met at Promontory Summit, Utah and the nation was linked by rail. During the ensuing year, 150,000 passengers made the journey between Omaha and Sacramento. A decade later, the figure approached 1 million. "A journey over the plains was a formidable undertaking, requiring great patience and endurance" reported Frank Leslie's Illustrated Newspaper. "Now all that has changed. . . the six months' journey is reduced to less than a week." And thus the way for people to come West had been eased, and the heavy flow of goods between the frontier and the rest of the nation had begun.

At the outset of the 19th century, the nation's leaders expected that it would take 500 years to settle the West. Instead, the 1890 census declared the frontier closed. What made the dif-

Hollywood liked to portray them as stalwart champions of justice. Bat Masterson called them ordinary men "who could shoot straight and had the most utter courage and perfect nerve - and, for the most part, a keen sense of right and wrong." But neither Hollywood nor Masterson caught the true measure of the law enforcement officer, for more often than not he was a shady character, one who was closer in spirit to the outlaws he was sworn to apprehend than he was to the citizenry in his care. The townfolk didn't really mind if he had been an outlaw before he became a marshall, or if he invested in saloons or brothels as a side-

line as long as he could keep the peace. In areas rife with troublemakers - notably the cowtowns and mining towns - such a pragmatic attitude was perhaps understandable. But, even in the most raucous of communities, gun battles and fistfights were not what occupied the major part of a marshall's time. He spent a good portion of each day doing paperwork. He issued licenses to brothels and saloons, served as the sanitation inspector, and collected taxes (taking a share of the proceeds for himself). Even Wild Bill Hickcok, the marshall of Abeline, Kansas, had to keep the streets litter free and patrol for unlicensed dogs. But the local marshall wasn't alone; he was part of a network of frontier law enforcement officers that also

included county sheriffs and, in a few states, quasi-military outfits, like the Texas Rangers. At the pinnacle of this network was the U.S. marshall, appointed by the president to oversee a state or territory. These were political figures. In Colorado, for example, a wholesale liquor dealer was a federal marshall, as was a bank appraiser. Fellows like these usually left the earthier aspects of the job to their deputies.

Hollywood liked to portray them as stalwart champions of justice. Bat Masterson called them ordinary men "who could shoot straight and had the most utter courage

and perfect nerve - and, for the most part, a keen sense of right and wrong." But neither Hollywood nor Masterson caught the true measure of the law enforcement officer, for more often than not he was a shady character, one who was closer in spirit to the outlaws he was sworn to apprehend than he was to the citizenry in his care. The townfolk didn't really mind if he had been an outlaw before he became a marshall, or if he invested in saloons or brothels as a side-line as long as he could keep the peace. In areas rife with troublemakers - notably the cowtowns and mining towns - such a pragmatic attitude was perhaps understandable. But, even in the most raucous of communities, gun battles and

172 173

The son of a Pennsylvania farmer, William Andrews Clark (1839-1925) went West, like so many others, to seek his fortune, but, unlike most, he found it. Starting as a peddler in the goldfields of Colorado, he entered the wholesale business, then went into banking and mining. He also acquired control of several newspapers in Montana and Utah, giant sugar plantations and rich oil-bearing land in California, and extensive real-estate holdings. He created the first water company in Butte, Montana, the first electric light company, and one of the first trolley car companies. In 1884, he decided to create a mansion befitting his station as one of the nation's wealthiest men. Three years later, the three-story, 30-room home designed in the Renaissance revival style by Los Angeles architect C. H. Brown was completed. It cost approximately $280,000 at a time when Clark's estimated earnings came to $17 million a month!

European craftsmen handcarved woodwork throughout the house and frescoed the ceiling of every room of the first two floors. The mansion boasted a 62-foot- long ballroom, stained glass windows by Louis Comfort Tiffany, fixtures fitted for incandescent lighting as well as gas, and an impressive main staircase with intricately carved panels of birds and flowers from various countries of the world. The latter, called "The Staircase of Nations," was removed from the house in 1903 and exhibited at the St. Louis World's Fair. Eventually, when Clark became a U.S. Senator, he erected a 121-room mansion in New York City. That structure was torn down, at his request, upon his death, but his home in Butte survived. The oldest mansion in Montana, it is privately owned by Mrs. Ann Cote Smith, who lovingly restored the home with

PAGE DESIGNS 2

These examples repeat the dirty orange layouts on pages 36 and 37. The first spread, like its cool counterpart on page 99, is too bright to look at for more than a moment. If you isolate the second layout, blocking out the other examples, the bright orange works reasonably well. However, one problem, at least in the United States, may be the strong Halloween color associations. Comparing this design with the cool blue version on page 99, notice how the warm color areas, particularly the "S," come forward, while the blue areas sink a bit more into the page.

The final design shows the danger of using large tint areas with a clean color. The 20% orange is a sherbert color. Used over such a large area, it tends to float off the page. The orange frame against the black panel looks too much like Halloween.

For the most part, they didn't huddle in ice-block igloos, as the stereotype would have it. Rather, the Eskimos lived in semi-subterranean dwellings of driftwood and sod. While these houses were small - 14 feet on average - they often boasted trim wood planks on the floor and walls. There were wooden sleeping platforms as well, and sometimes even cupboards. Long entrance tunnels, which were lower than the rest of the structure, kept the cold out of the main dwelling, and seal oil or wood fires kept things toasty. Eskimos lived in

S o they were sailors and shopkeepers, clerks and soldiers, dreamers from every walk of life, who dropped what they were doing with the news of a strike to pursue their luck in the gold- and silverfields of the West. They came in droves. Indeed, it is estimated that 80,000 fortune-seekers made the jour-

ney to California in 1849 alone. Most of them could barely afford a pick, a pan, a mule, and some food. Consequently, the methods that they used for finding gold were rather unsophisticated. The most popular approach called for the use of a pan with a pourous bottom - or a rocker or cradle - with which a prospector could sift a streambed, washing away the sediment with water while the heavier ore remained behind. Most worked long and hard in this fashion with little to show for their effort; they would have earned more per

THE SON OF A PENNSYLVANIA FARMER, WILLIAM ANDREWS CLARK (1839-1925) WENT WEST, LIKE SO MANY OTHERS, TO SEEK HIS FORTUNE, BUT, UNLIKE MOST, HE FOUND IT. STARTING AS A PEDDLER IN THE GOLD-FIELDS OF COLORADO, HE ENTERED THE WHOLESALE BUSINESS, THEN WENT INTO BANKING AND MINING. HE ALSO ACQUIRED CONTROL OF SEVERAL NEWSPAPERS IN MONTANA AND UTAH, GIANT SUGAR PLANTATIONS AND RICH OIL-BEARING LAND IN CALIFORNIA, AND EXTENSIVE REAL-ESTATE

COLOR TINTS

BLACK

BAR GRAPHS 1

These graphs are directly comparable to the dirty orange examples on pages 38 and 39, as well as the clean blue ones on page 100. The important point to keep in mind with graphs like these is that the function of the second color is to make it easier for the reader to take in the information. If the color is too loud, calling too much attention to itself, it is not working.

The most strident orange here is in the top right graph. In fact, the color is so overpowering that it may be best to mask this graph before you look at the others. The top left, middle right, and bottom right graphs are all possibilities (see the discussion on page 100). In the middle right graph, however, the 60% black bars may not be strong enough to keep the orange in a background position. This is more of a problem here than with the clean blue because warm colors tend to advance. Finally, for the bottom right graph, it might be better to use slimmer orange bars to reduce the glare between the orange and the white.

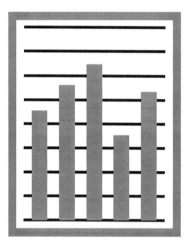
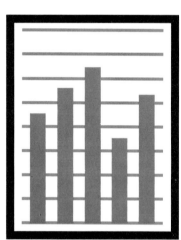
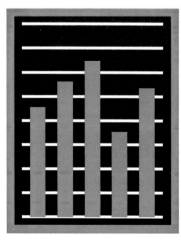
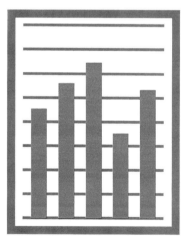

BAR GRAPHS 2

These graphs are warm versions of the ones on page 101. The first pair uses a 30% color background on the left and a 30% color plus 10% black background on the right—a definite improvement. Notice how the change in the background affects all the other elements. The orange frame, however, may still seem too bright; you might tone it down further by adding 10% black. But, then, why not use a dirty color to begin with, as on page 40? After all, each time you screen a color, it adds to the cost of the job.

In the middle pair the 100% color background on the left becomes 100% color plus 10% black on the right. Again, there is a distinct improvement with just a touch of black. The change in the grays is also worth noting both here and, even more, in comparison to the corresponding graph on page 101. Against orange—the lighter-value color—the gray appears much darker than against blue.

The last two graphs are comparable to the top right and middle left dirty orange graphs on page 41, as well as the process blue graphs on the bottom of page 101. They are examples of how you might use a pure color to advantage, for chromatic but readable results.

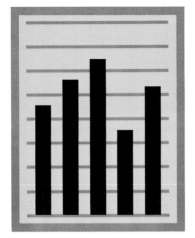 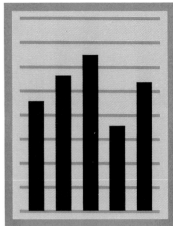

MAPS

The first map, with 60% orange toned down by 20% black, works just as well as the corresponding map on page 42, and it is more colorful. In the second map, however, the bright orange lines shimmer against the white, just as the process blue lines did on page 102. If the gray background were used inside the map, with the white as an overall background, the orange lines would not seem as bright.

The third map suffers from the same problem as the bottom blue map on page 102. The 20% orange tint takes over. Instead of functioning as a neutral background, it competes with the map for attention.

On the next page the top map is comparable to the top map on page 43. Here, however, the full-strength color area may seem too bright, even though it is toned down by the tint of 40% color and 10% black that surrounds it. In a situation like this, you may want less contrast to keep the map unified as a whole.

The last map, which uses various combinations of color and black, as well as a light black tint, is quite effective. With black instead of orange outlines for the states, the map itself is more readable than the dirty orange version on page 44. If you must use a clean color for some other reason—such as a corporate logo—then combining tints with black is a workable, although more costly, solution.

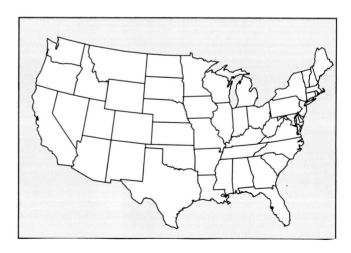

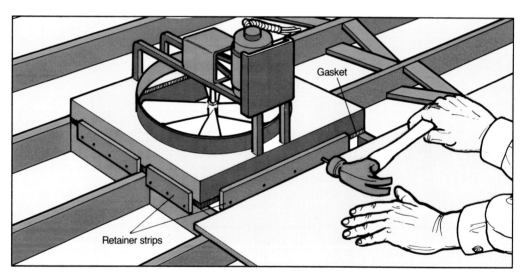

DIAGRAMMATIC ART

In both these examples, the clean orange may be a bit too bright for the prolonged study that a reader might find necessary with do-it-yourself instruction. The dirty orange examples on page 46 are certainly easier to look at. The orange, however, is not as bright as it could be. In the top example, it is toned down by all the surrounding gray. In the bottom example, it is kept in place by the gray and pale (10%) orange tints (see the discussion on page 104).

ART WITH LINE AND TONE

The bright orange does not seem as appropriate for these illustrations as the dirty orange on pages 48 and 49. In the top illustration the bright orange calls too much attention to itself as a color, while in the bottom illustration it seems to fight the gray, making the drawing hard to read. In general the dirty orange seems more natural.

PHOTOGRAPHS OF PEOPLE 1

The glaring orange in the top and bottom photographs makes this page hard to look at. Clearly, a dirty orange, like the one on page 50, is more appropriate when you intend to use full-strength color.

The middle version, with a 30% background tint of orange, is much more believable—especially if you mask out the top and bottom images. If this color seems too sweet for the context, you might try an even paler tint. Another possibility would be to use a pale tint with a silhouette, as in the middle example on page 106.

PHOTOGRAPHS OF PEOPLE 2

These duotones combine a normal halftone in black with a normal halftone in color (top), a flat halftone in color (middle), and a dropout halftone in color (bottom). Pairing an orange halftone with a black halftone clearly tones down the brightness of the orange. In essence you are mixing the orange with black, creating dirty tones.

Now compare these duotones with the dirty orange ones on page 51. Immediately you'll notice how much more colorful the images here are. At the same time these images are flatter, less dimensional, than their counterparts. Which you prefer depends not only on personal taste, but more importantly on how you intend to use the image. If, for example, you are planning to have a page full of different head shots, you may find the duotones here a bit too orange. But if you have just one small image on a page that is grayed with type, you may want the warmth the bright orange provides.

PHOTOGRAPHS OF PEOPLE 3

For photographs, a good way to use a bright clean color is with a special-effect technique. These three pairs are directly comparable to the examples in dirty orange on page 52. The first pair—a color posterization and a black normal halftone—is much more orange with the clean color. In some contexts it could be effective; in others you might prefer the more neutral dirty orange.

The second example—combining two needlepoint-like line screens —is also very orange with the clean color. Here, however, the image as a whole is more abstract, so the added color does not seem unrealistic. The stronger visual excitement of the pure orange may even be an asset here.

The last example—a black solarized halftone and a color line conversion—is an unusual image, in which any color would function decoratively rather than naturalistically. Whether you choose a muted or a bright orange here depends mostly on the context and your personal taste.

PHOTOGRAPHS OF OBJECTS

These two images make use of special-effect techniques. On the left a
needlepoint-like screen in color is combined with a posterized version
of the same screen in black—the reverse of the left image on page 59.
The clean orange result seems less colorful than the dirty orange
image because of the reversal of the screens. Had the clean orange
been used in the same way as the dirty orange, the coloring of the
light tubes would be more like that of the tubes in the other image. As
this example clearly shows, which screen you print in color can make
a big difference. It is best to ask the printer or separator for advice.

In the right image, where a color solarization is used with a black line
conversion, the result is a warm version of the dirty blue image on
page 91. If the plates were reversed, the result would be similar to the
solarization at the bottom of the preceding page.

BIBLIOGRAPHY

Albers, Josef. *Interaction of Color*. New Haven: Yale University
 Press, 1963.
Aldrich-Ruenzel, Nancy, ed. *Designer's Guide to Print Produc-
 tion*. New York: Watson-Guptill Publications, 1990.
Bann, David. *The Print Production Handbook*. Cincinnati: North
 Light, 1985.
Beach, Mark; Steve Shepro, and Ken Russon. *Getting It Printed*.
 Portland, Ore.: Coast to Coast, 1986.
Craig, James. *Production for the Graphic Designer*, 2d ed. New
 York: Watson-Guptill Publications, 1990.
De Grandis, Luigiana. *Theory and Use of Color*. Englewood
 Cliffs, N.J., and New York: Prentice-Hall and Harry N.
 Abrams, 1984.
Demoney, Jerry, and Susan E. Meyer. *Pasteups and Mechanicals*.
 New York: Watson-Guptill Publications, 1982.
Favre, Jean-Paul, and Andre November. *Color and Communica-
 tion*. Zurich: ABC Verlag, 1979.
International Paper Company. *Pocket Pal*. New York: Internation-
 al Paper Company, 1983.
Itten, Johannes. *The Elements of Color*. New York: Van Nostrand
 Reinhold, 1970.
Sanders, Norman. *Graphic Designer's Production Handbook*.
 New York: Hastings House, 1982.
S. D. Warren Company. "Black Halftone Prints." Boston: S. D.
 Warren Company, Bulletin #3, 1980.
____. "How to Plan Printing." Boston: S. D. Warren Company,
 1988.
____. "The Influence of Paper on Color Printing." Boston: S. D.
 Warren Company, Bulletin #2, 1980.
White, Jan. *Color for the Electronic Age*. New York: Watson-Gup-
 till Publications, 1990.

INDEX